IMAGES
of America

SUFFOLK AND NANSEMOND COUNTY

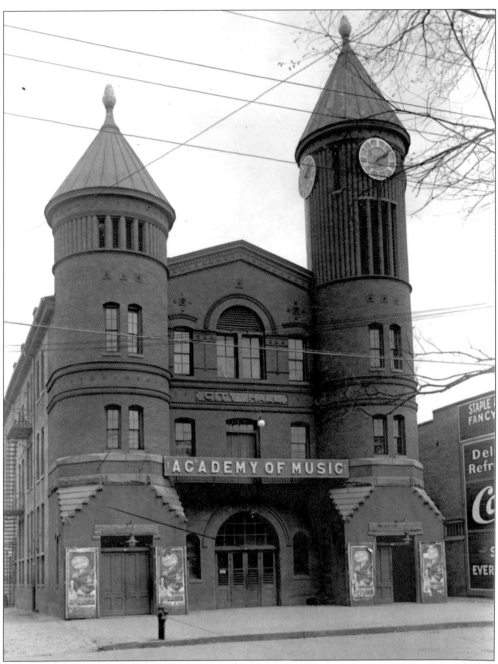

The Academy of Music, completed in 1891, was a center of activity for Suffolk and Nansemond County. Kids played ball nearby while others took dance lessons and performed in plays inside. The Academy, pictured here in 1920, was located on North Main Street and offered theaters for acting, music, and dance performances. In later years the building housed City Hall offices as well as a market on the first floor. G.T. Moody, J.H. Stone, Kelly and Lassiter, and W.P. Mitchell and Sons were some of the merchants that had stalls in the market in the early 1900s. The performance advertised on the posters by the door was for *The Girl and The Game*. (Courtesy of the Library of Virginia.)

IMAGES
of America

SUFFOLK AND NANSEMOND COUNTY

Frances Watson Clark

ARCADIA

Published by Arcadia Publishing,
an imprint of Tempus Publishing, Inc.
2 Cumberland Street
Charleston, SC 29401

Printed in Great Britain.

Library of Congress Catalog Card Number: 2001098970

For all general information contact Arcadia Publishing at:
Telephone 843-853-2070
Fax 843-853-0044
E-Mail sales@arcadiapublishing.com

For customer service and orders:
Toll-Free 1-888-313-2665

Visit us on the internet at http://www.arcadiapublishing.com

*This book is dedicated to my mother, Marion Fendall Joyner Watson,
who served as the guardian of Suffolk's history all of her life and helped
preserve its legacy for future generations.*

CONTENTS

ACKNOWLEDGMENTS

The research and development of this book is a tribute to my mother, Marion J. Watson, who passed away in 1996. It is because of her devotion and dedication to the preservation of the history of Suffolk that I decided to take on this assignment. As I went through the Suffolk Nansemond Historical Society files and pictures that she painstakingly helped put together, her notes and descriptions guided me. I would like to give special thanks to Sue Woodward, president of the Historical Society, for her help and for carrying on where my mother left off. I also thank the board of directors of the society for allowing me access to the information and pictures.

I am grateful to Lee and Henrietta King, who were good friends of my mother's and are a wealth of knowledge. I want to acknowledge Robin Rountree of Riddick's Folly for putting up with my questions and constant visits. Lee Hart, who also worked closely with my mother, was another source of information that helped make this book a success.

Photographs in this book tell an intricate story of how a town developed and prospered. I am grateful to Audrey C. Johnson, Picture Collection Coordinator of the Library of Virginia, for helping me with The Hamlin Collection.

I would like to thank my uncle, Dick Joyner, who remembers more than he cares to admit, and my aunt, Betty Birdsong Joyner, who was able to identify all of her relatives and other people that no one else knew. Daphne Chapman, a dear friend, not only identified people, but also told me stories that brought them to life. Bill Chpman also assisted by sharing his memories. I wish to acknowledge Tracie Murratti for her help with caring for the family while I was involved in the research and writing of this book.

My appreciation of and love of writing comes from my father, William Thomas Watson, and I am grateful for the gift he has given me.

Special thanks to my editor, Laura Daniels, for her patience with me as I learned to use the electronic tools of my trade and her guidance in the whole process.

Finally, I would like to acknowledge my husband, Chris Clark, and my children, Katherine and Philip Worrell, for their loving support during this endeavor. They tried to stay out of my way and relinquished the dining room to my pictures and papers so that I could stay organized. I have written this book in memory of my mother and I hope that her grandchildren will remember what she taught them about the city she loved and will pass her legacy on to their children.

INTRODUCTION

Suffolk and Nansemond County were created from a large and diverse area in the southeastern part of Virginia. The city survived war, weather, and other outside forces and became a municipality strengthened by the people who built it and those who live there today. The city has been a large contributor to the Tidewater Region by serving as a distribution center and transportation hub connecting the surrounding population to the state and the world. Politically, Suffolk has contributed two ambitious and accomplished governors. Richard Bennett, of the Bennett's Creek area, served as the first governor of Virginia under Oliver Cromwell's England from 1652 until 1655. Another son of Suffolk, Mills E. Godwin Jr., was elected governor of Virginia first in 1965 and again in 1973.

Suffolk is best known for its peanuts. One of the first peanut crops in America was planted near Suffolk. The business community is largely made up of farmers that cultivate the crop, businessmen who bring it to market, and companies that make various products from it. Planters Peanut Company, established in 1913, is a nationally known firm that has grown with the town and its surrounding areas, and still flourishes today. For many years Suffolk was unofficially known as "The Worlds Largest Peanut Market."

Suffolk and Nansemond County started their meager beginnings on the banks of a river named for the local Native American tribe, Nansemond. Capt. John Smith, one of the founders of the Jamestown Colony, visited the area in 1608, but the Nansemonds forced him to leave. He left, but others soon followed. The county of Nansemond was formed in 1642, and the town of Suffolk was created 100 years later in 1742, from Constant's Wharf. John Constant's family was one of the first to settle there. The town was named after Gov. William Gooch's original home, which was in Suffolk County, England.

Constant's Wharf, the crossing area for the Nansemond River, was the center of town and served as a landing for ships coming up the river. Road transportation in Suffolk helped the town serve as the stopping point on the way to and from North Carolina. There were a number of inns that welcomed tradesmen, newcomers, and travelers.

General Lafayette visited Suffolk on February 25, 1825 as part of his tour celebrating the American victory. He dined at the courthouse with the town's prominent residents and stayed at Castle Inn. Castle Inn, which was located at 444 North Main Street, was popular with travelers in the 18th century and well into the 19th century. It was destroyed by fire in 1837.

Fire would prove to play a major role in shaping Suffolk. Several fires on Main Street would affect the growth and history of the town. The first one was the burning of the town by the

British. The next fire, on June 3, 1837, soon became know as "The Great Fire." It destroyed most of the structures in its path from Mahan Street to the courthouse. One hundred and thirty buildings were lost—many of which were private residences. The last major fire occurred on February 7, 1866 at the city clerk's office. All of the records up to that date were destroyed, leaving a huge void in the historical records of the town.

During the Civil War, Suffolk did her part to support the Confederate effort. The Union Forces occupied the town in May 1862. The Union soldiers took over many of the residences and either destroyed or stole most of the supplies and possessions of the occupants. There were rumors of residents burying valuables in the ground before they had to flee. Confederate troops tried to take the town back in the spring of 1863 but were unsuccessful. During the Union army occupation, Riddick's Folly, a prominent home on Main Street, was used as the headquarters for General Peck.

As with most southern communities after the war, reconstruction brought about many changes in Suffolk. In the late 1800s and early 1900s, many new businesses appeared in the area and with them came new residents and newfound prosperity. Two separate schools were built—one for whites and one for blacks—and the peanut industry started to bloom. Planters Nut and Chocolate Company started by Amedeo Obici put Suffolk on the map. Transportation was a central factor in the growth. Six different rail lines moved manufactured and agricultural goods to and from the city. The rail also brought people—some visited and left while others stayed to work and raise their families. There are many generations of families represented in Suffolk today that have great and great-great grandparents who settled there.

Suffolk grew in the 1920s and 1930s, and by World War II, the city again offered its sons and daughters to help in the war effort. Many residents supported the effort at home while others went off to fight. On May 21, 1928, a small group of men in Holland decided to form an organization to perform community service. It was the creation of the first Ruritan Club in the United States. The group was established to help make rural communities better places to live. The national organization still exists today and has clubs across the country.

After the war, Suffolk continued to expand and fully establish itself in the area. In 1972, Nansemond County combined with Holland and Whallyville to form the city of Nansemond. In 1974, the cities of Suffolk and Nansemond merged to form the present-day city of Suffolk. Suffolk continues to grow and prosper with developments in industry, recreation, education, and government always emerging to improve the quality of life for its people.

One
BUSINESS, COMMUNITY, AND GOVERNMENT

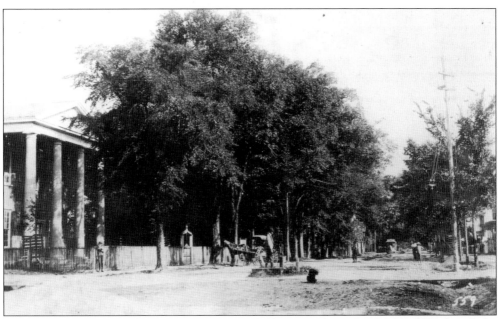

This photograph was taken on Main Street looking up from Constant's Wharf and the Nansemond River. This view is much like the one newcomers to the area would have seen when they arrived by coach, boat, horseback, or on foot. This is the same area that was devastated by the three fires that hampered the growth of the city. The courthouse on the left was built in a Greek revival style c. 1837. (Courtesy of the Suffolk-Nansemond Historical Society.)

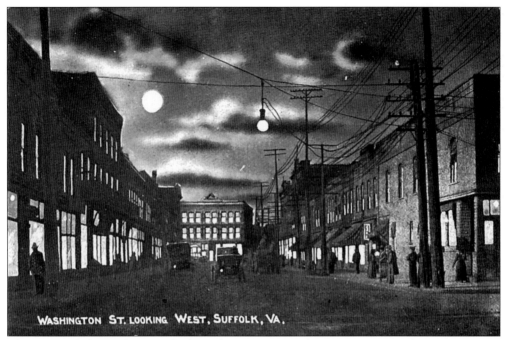

WASHINGTON ST. LOOKING WEST, SUFFOLK, VA.

This postcard shows the view looking down West Washington Street in the evening. It is typical of many of the postcards of the day. (Courtesy of the Marion J. Watson Collection.)

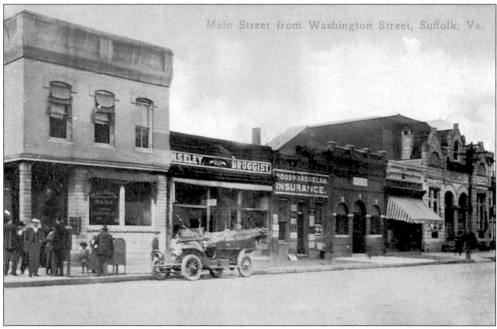

Main Street from Washington Street, Suffolk, Va.

On this postcard is a section of North Main Street. The buildings, from left to right, are the Old Virginia National Bank, a drugstore named Eley, and the Woodward and Elam Insurance Company. Two buildings down from Woodward and Elam is the Bank of Suffolk. (Courtesy of the Marion J. Watson Collection.)

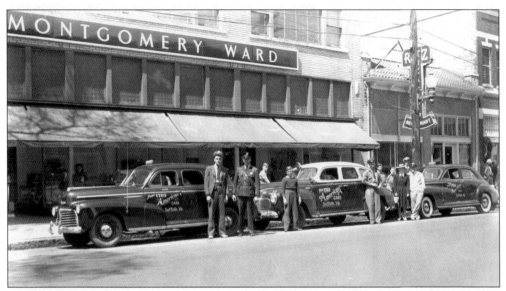

Cab drivers of the American Cab Company posed for a picture while talking to a local police officer. They are standing in front of Montgomery Ward on North Main Street. The Ritz, to the right, was a restaurant popular with businessmen and families for many years. (Courtesy of the Suffolk-Nansemond Historical Society.)

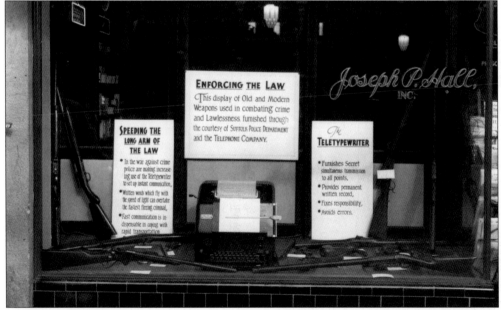

Joseph P. Hall Sr. established the Joseph P. Hall Drugstore in 1837. The store later offered its patrons an elevator to the third floor as well as recorded music to entertain them while they shopped—extravagant features for that time. Ownership and operation of the store was handed down from one generation to the next. By 1915, the store had two locations on 918 and 920 Washington Street. The window display is of old and modern weapons used to combat crime. The Suffolk Police Department and the Telephone Company provided the items. Pictured are various guns and a Teletype machine; it was used to transmit information about criminals so they could be apprehended. (Courtesy of the Suffolk-Nansemond Historical Society.)

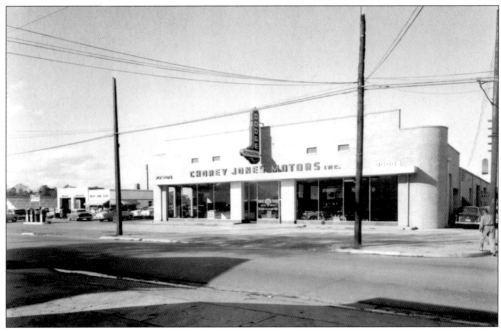

Chorey Motors was first established by Vincent Chorey in 1938. In the 1950s, it was located at 800 and 802 West Washington Street. They had a 10,000-square-foot service department. To the left of the showroom is the Westside Esso station. This photograph was taken October 29, 1954. (Courtesy of the State of Virginia Library.)

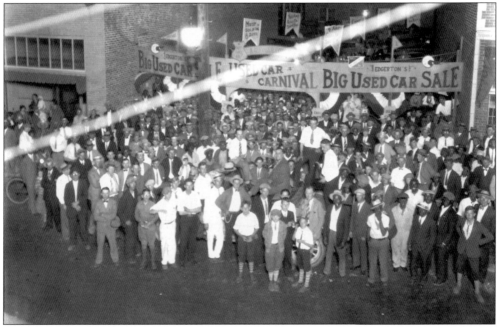

Edgelston Automobile was at one time located at 1215 and 1217 West Washington Street. R.G. Edgelston was a leader in the automotive industry in Suffolk. In the early 1900s, Edgelston sold Hudson, Reo, and Maxwell automobiles. This picture c. 1920 shows the turnout at a used car carnival held on the lot. (Courtesy of the Suffolk-Nansemond Historical Society.)

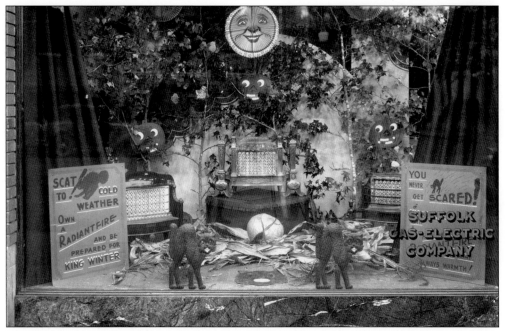

The Suffolk Gas Corporation was the main supplier of gas in the community for many years. Gas was first used in Suffolk in April 1904 and natural gas was first used in 1951. The Suffolk Gas-Electric Co. window displayed several modern heaters called Radiantfire heaters and a Halloween motif with pumpkins and black cats. The slogan "Be prepared for King Winter" is advertised. (Courtesy of the Suffolk-Nansemond Historical Society.)

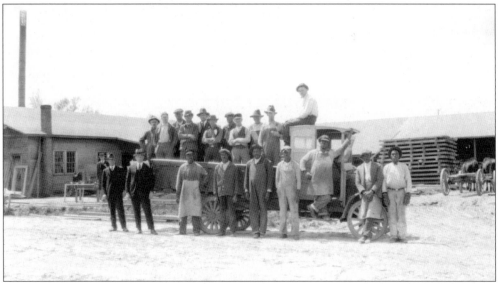

Mr. B.D. Crocker founded Suffolk Lumber Company. The company had a mill, woodworking shop, lumberyard, and several warehouses. After Mr. Cocker's death in 1931, his heirs carried on the business. In the 1950s, the company was located at Mulberry and Jefferson Streets and was billed as the oldest continuously operating lumber firm in the area. The company was eventually closed. In this picture, workers and management pose for the camera. (Courtesy of the State Library of Virginia.)

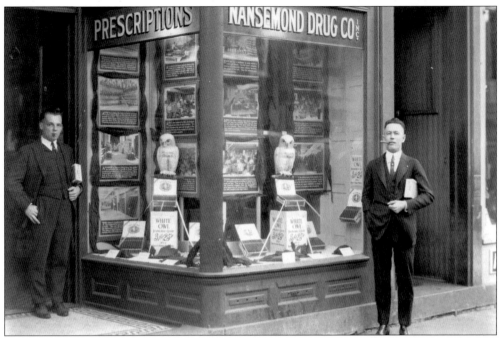

Nansemond Drugstore was owned by Fredrick Lee Hart Sr. His father, Maj. Spencer Lee Hart III, fought in the Spanish American War. Hart owned the store from the early 1900s until 1938 when he sold it to Barry Fitzhugh. Fitzhugh in turn sold it to Dave Hopewell who owned the store until it was closed in the 1990s. Two men are standing outside a window display of cigars at the Nansemond Drugstore after making their cigar purchases. The window display shows the process of making cigars from tobacco in the fields to manufacturing and shipping. (Courtesy of the Suffolk-Nansemond Historical Society.)

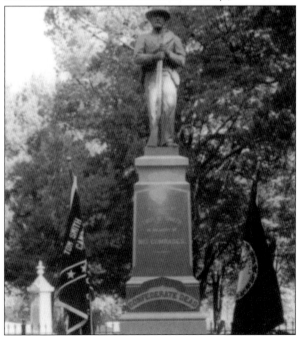

The Confederate Monument in Cedar Hill Cemetery was dedicated on November 14, 1889. Col. Thomas W. Smith commissioned it in memory of the soldiers he fought with in the Confederate army. Jno. P. Hall Co. of Norfolk, Virginia helped construct the granite monument, but the soldier, made of white bronze (zinc), was cast in Bridgeport, Connecticut. A parade through the streets included the "Suffolk Grays" (the cadets of the Suffolk Military Academy), and many Confederate veterans. Guest of honor and keynote speaker Gov. Fitzhugh Lee reviewed the participants. (Courtesy of The Tom Smith Camp #1702, Sons of Confederate Veterans.)

The first dairy in Suffolk was located at this farm in the early 1900s. In this photo, from left to right, are Anona Howell (seated), Anona Johnson Howell, Clinton ?, Luemma Johnson, John Aaron Johnson, Magweed ?, and Lewis Warren ?. The photograph was taken on September 10, 1905. (Courtesy of the Suffolk-Nansemond Historical Society.)

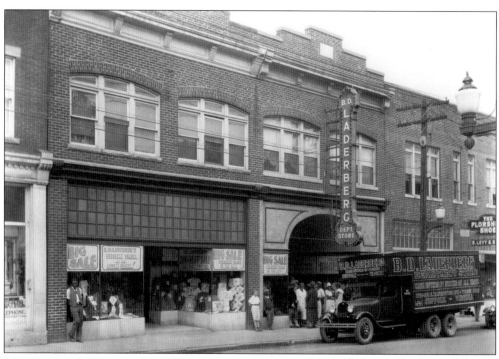

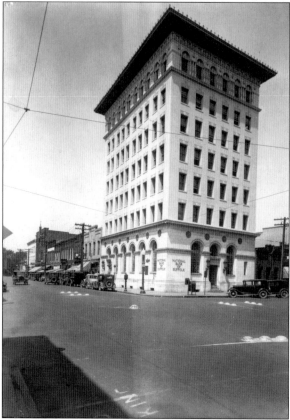

B.D. Laderberg's Department Store was owned by B.D. and Dora Laderberg and was located at 179 East Washington Street. They opened the store in 1916 and several generations of the Laderberg family owned the business in later years. In a 1958 advertisement, the store was advertised as "Suffolk's Largest Independent Department Store." (Courtesy of the Suffolk-Nansemond Historical Society.)

"The Square" in downtown Suffolk was home to the National Bank of Suffolk. The bank was established in 1899. The original officers of the bank were James L. McLemore, president; R.A. Pretlow, vice-president; A. Woolford, cashier; and C.E. Hargrave, teller and bookkeeper. The bank began with capital accounts of $6,200 and total assets of $7,802. This building at the corner of Washington and Main Streets was the second location of the bank. (Courtesy of the Suffolk-Nansemond Historical Society.)

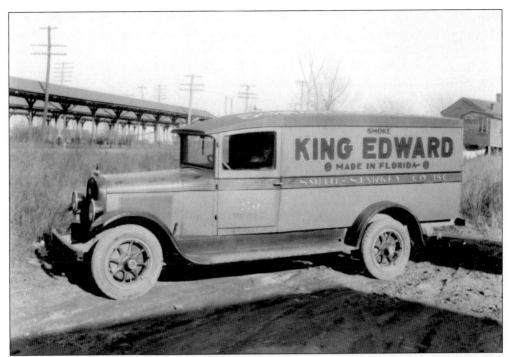

This Smith Starkey Inc. truck advertised King Edward cigars for 5¢. The company sold cigarettes, cigars, candies, and other sundries. The telephone number on the side of the truck was 270, only three digits. (Courtesy of the State Library of Virginia.)

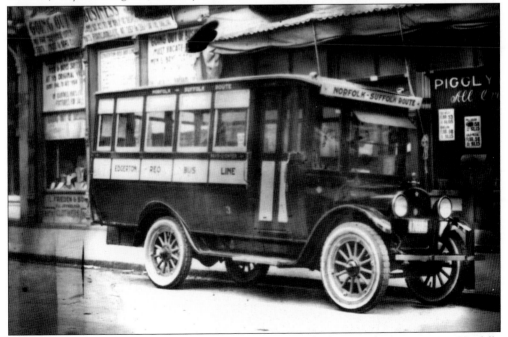

R.G. Edgelston also ran the Edgerton Reo Bus Line, which carried passengers to Norfolk, Smithfield, and Franklin. The bus parked in front of the Piggly Wiggly grocery store. (Courtesy of the Suffolk-Nansemond Historical Society.)

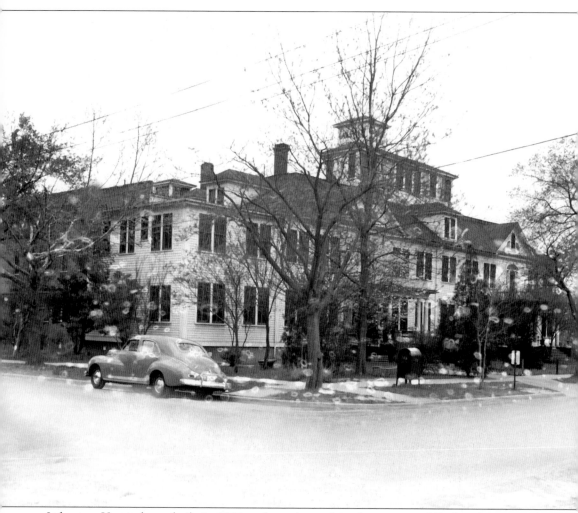

Lakeview Hospital was built in 1906 and was located at the corners of Bosley Avenue and Smith Street. There were 12 patient rooms. The first staff included Dr. J.E. Rawls, Dr. E.R. Hart, and Dr. D.L. Harrell. As the hospital expanded and specialists were needed, the administrators added more staff and more rooms. In 1918, a school of nursing was added. The hospital and nursing school operated until September 1951 when Obici Hospital replaced it. The nursing school students also transferred to the nursing school at Obici. In 1952, Lakeview Clinic was built adjacent to the new hospital to house the doctors' practices and the old hospital was torn down. The staff at Lakeview Clinic included Dr. W.T. Gay, Dr. J.R. Ellison Jr., Dr. W. Holmes Chapman Jr., Dr. J.M. Habel Jr., Dr. W.H. Rogers, Dr. J.E. Rawls Jr., Dr. M.M. Bray, Dr. C.H. Rawls, and Dr. D.B. Corcoran. (Courtesy of the Library of Virginia.)

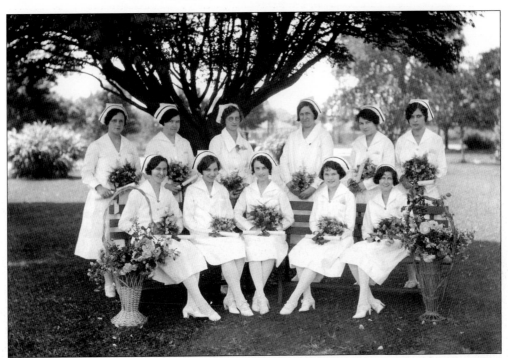

The Nursing School of Lakeview Hospital produced a number of nursing graduates who worked at Lakeview as well as other local hospitals. This is a picture taken of one of the graduating classes with their diplomas in the 1920s or 1930s. (Courtesy of the State Library of Virginia.)

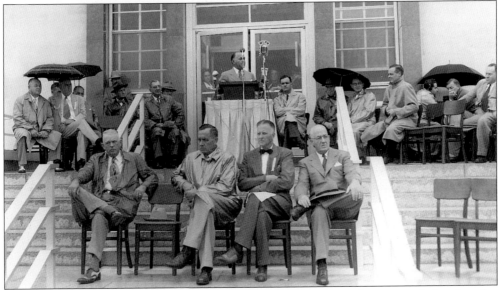

Obici Hospital opened its doors to the public in 1951. The hospital was named after Amedeo Obici's wife, Louise. He founded the hospital in memory of her and provided the funds to build it. When he died, their bodies were interred in the hospital lobby behind pictures of themselves. This picture includes (front row third from the left) Dr. G.R. Joyner Sr., the first president of the hospital, and (to the right of the speaker) Mills E. Godwin Jr., two-time governor of Virginia. (Courtesy of the Marion J. Watson Collection.)

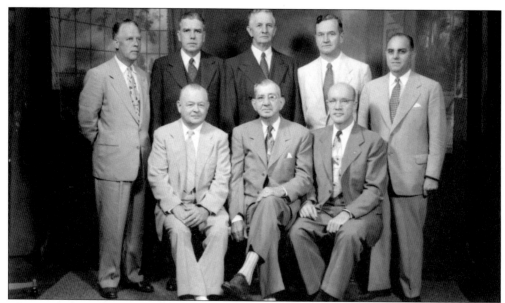

The board of directors for the newly opened Louise Obici Hospital in Suffolk was made up of a number of prominent businessmen in the city. The members were, from left to right, (front row) Lewis Cathey, Mac Cross, and Harry Pettit; (back row) William M. Birdsong, James Causey, Dr. F. Whitney Godwin, Vernon Eberwine, and Michael English. This picture was taken in 1951, commemorating the opening of the hospital. (Courtesy of the State Library of Virginia.)

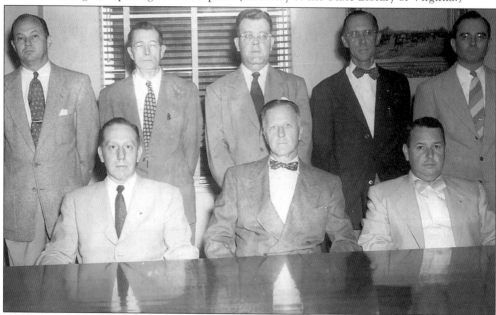

The first staff of Obici Hospital in 1951 was made up of a number of local doctors in the area. The doctors, from left to right, are (front row) Dr. Beverly Holladay, general practitioner; Dr. George Richardson Joyner Sr., pediatrician; and Dr. James Habel, ob-gyn; (back row) Dr. John Norfleet, dentist; Dr. W.T. Gay, surgeon; Dr. Ike Steele, general practitioner; Dr. Ed Joyner, general practitioner; and Dr. William Holmes Chapman, internal medicine. (Courtesy of the Marion J. Watson Collection.)

The American Legion commissioned a monument to honor the memory of the men of Suffolk and Nansemond County who lost their lives in World War I. The effort to build the statue was spearheaded by Dr. F. Whitney Godwin and funds were donated from individuals and organizations. Joseph P. Pollia, a sculptor from New York, created the statue. The figure, *The Doughboy at Rest*, was originally placed at the intersection of North Main Street and Milner Street on May 11, 1931. Many residents of the community attended the dedication ceremony. As Suffolk grew and traffic on North Main Street increased, it was necessary to move the monument to the entrance of Cedar Hill Cemetery. (Courtesy of the Suffolk-Nansemond Historical Society.)

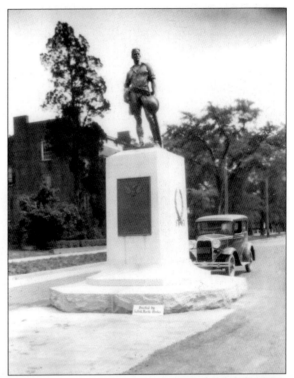

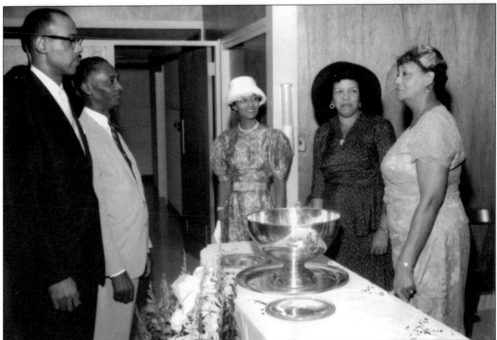

The Hoffler Medical Center, located on Madison Avenue, was established to serve the medical needs of the black community. The hospital was run by Dr. Oswald W. Hoffler, a highly respected physician in the town. This picture is of the open house held there on October 12, 1959. (Courtesy of the State Library of Virginia.)

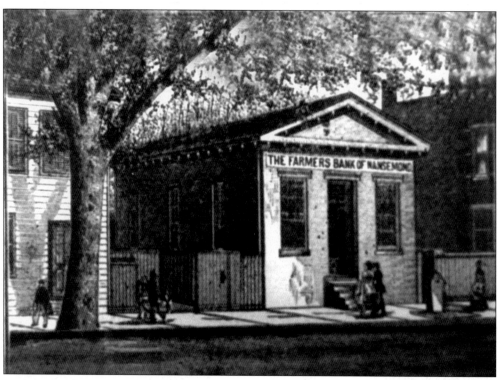

DEPOSITED WITH

FARMERS BANK OF NANSEMOND,

BY

_____ _188_

as follows :

	DOLLARS.	CENTS
Currency, - - - -		
Gold, - - - -		
Silver, - - - -		
Checks and Drafts, - -		
(ENTER SEPARATELY)		
Total, - - - -		

Col. John R. Copeland created the Farmers Bank of Nansemond on November 30, 1869 with several of his friends. Industry was coming to Suffolk after the Civil War and Colonel Copeland wanted to establish a bank to help businessmen and families with the new growth on the way. The first location of the bank was the corner of Washington Street and the street that is South Saratoga Street today. The bank paid $2 per month to rent the offices and opened for business on January 1, 1870. The second Farmers Bank of Nansemond, pictured above, was located on Main Street and had been previously used as the Suffolk Savings Bank. (Courtesy of the Suffolk-Nansemond Historical Society.)

This is a receipt from the Farmers Bank of Nansemond _c._ 1800. It lists, currency, gold, silver, checks, and drafts. (Courtesy of the Suffolk-Nansemond Historical Society.)

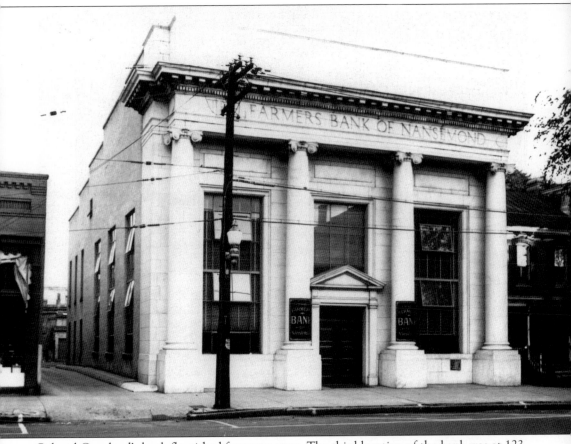

Colonel Copeland's bank flourished for many years. The third location of the bank was at 123 North Main Street. The building was made of stone and remained at that address from 1899 until it was torn down in 1922. SunTrust occupies the building on the site today. (Courtesy of the Suffolk-Nansemond Historical Society.)

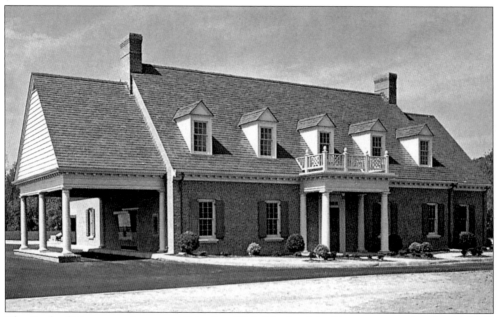

The Bank of Nansemond was established in 1963. The bank building was completed in 1964. It was located on route 17 at the intersection of Route 701 near Bennett's Creek in the northern part of what was then Nansemond County. The president of the bank was J.L. Edwards Jr. and the cashier was Earl T. Eberwine. Other directors of the bank were Bertram S. Hazelwood, R. Moore Williams, T.A. Saunders Jr., William W. Jones, Gordon W. Jones, and Kenneth L. Kirkland. (Courtesy of the Marion J. Watson Collection.)

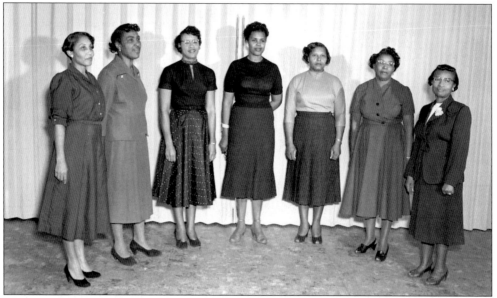

The Nansemond Credit Union was created in 1949. The first president and founder was Rev. C.J. Word, pastor of the East End Baptist Church. The first site was in a building the Credit Union shared with Vaughn's Printing Shop. The Credit Union moved to Tynes Street and finally moved to its present site at 617 East Washington Street. The picture shows employees of the Credit Union on October 27, 1955. (Courtesy of the State Library of Virginia.)

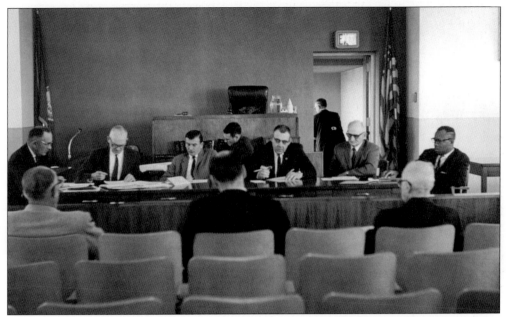

Pictured above is a session of the Nansemond County Board of Supervisors. The men seated at the table are, from left to right, Jarvis Harvell, George Cornell, Lester Mansfield, Joe Savage, Al Glasscock, and Moses Riddick. Robert Gillette is in the background. In 1972, Nansemond became a city and changed to a mayor and city council. The mayor was D.J. Mangum Jr., the vice-mayor was Moses Riddick, and councilmen were Howard L. Munford, John W. Nelms Jr., and Joseph A. Savage. Moses Riddick later served as vice-mayor for the city of Suffolk in the mid-1970s. (Courtesy of the Suffolk-Nansemond Historical Society.)

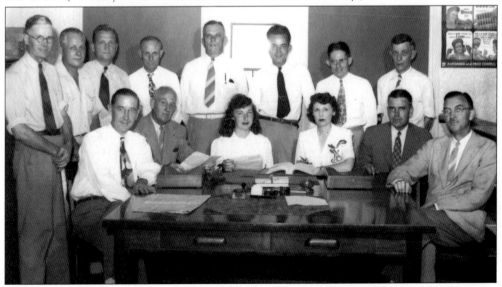

During World War II, citizens of Suffolk had to sacrifice for the war effort when certain items had to be rationed due to shortages. Ration books were distributed to residents with the proper identification for gas, processed foods, meats, sugar, and more. The Ration Board in Suffolk, above, met to review regulations in 1941. (Courtesy of the Suffolk-Nansemond Historical Society.)

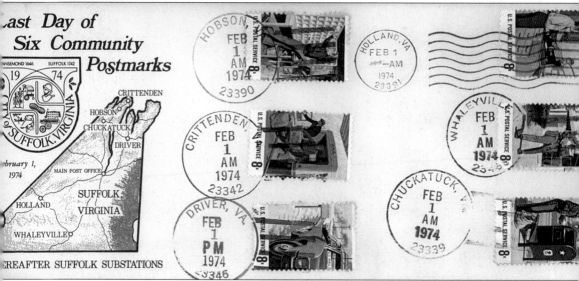

By 1972, Nansemond County had become the city of Nansemond. Two years later, in 1974, the area that made up the city of Suffolk and the city of Nansemond merged to form present-day Suffolk. The merger created the largest city in land area in Virginia. The communities of Hobson, Crittenden, Driver, Holland, Whaleyville, and Chuckatuck became substations. This is a last day cover issued to commemorate the occasion with postmarks from the substations. (Courtesy of the Marion J. Watson Collection.)

The Birdsong Recreation Center was built in the summer of 1958. The Birdsong Trust Fund provided the funds used to build the facility. The center, created to provide a place for young and old alike to play ball, take lessons, and hold community activities, was used for many years as the gym for Suffolk High School. It was also utilized for dances, concerts, and dance classes.

Colonial Stores employees display items for sale at the Colonial Stores in the area. On display were a Handy Freeze Ice Cream Maker, a gun, and a toaster. Colonial Stores served residents needs well into the 1960s as a grocery store chain. This picture was taken January 28, 1950. (Courtesy of the State Library of Virginia.)

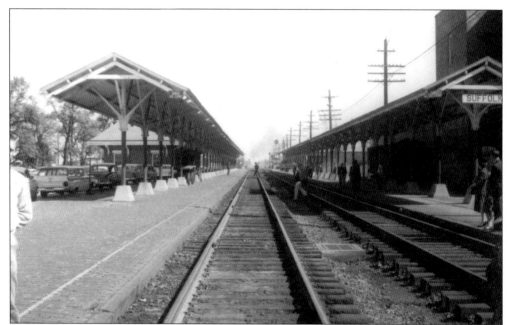

This photo of the Norfolk and Western Station, referred to as Union Station, was taken in 1955. The Norfolk and Western was just one of six lines that ran through and served Suffolk. The others were the Seaboard Air Line, the Atlantic Coast Line, the Virginian, the Southern, and the Norfolk-Southern. They each had two passenger runs per day in the early 1900s. Freight trains also ran through town in an almost endless stream. (Courtesy of the Suffolk-Nansemond Historical Society.)

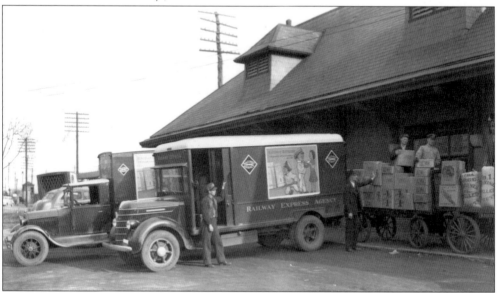

Businesses in Suffolk relied on the train service to carry goods to far-reaching companies across the country. At the Norfolk and Western depot, RR Express Agency delivers and picks up goods. At the end of the truck is Mr. Pharish, the RR Express agent. Standing on the platform at left is Mr. Byrd and on the right is Mr. Simeon Nixon. This picture is dated March 4, 1940. (Courtesy of the Suffolk-Nansemond Historical Society.)

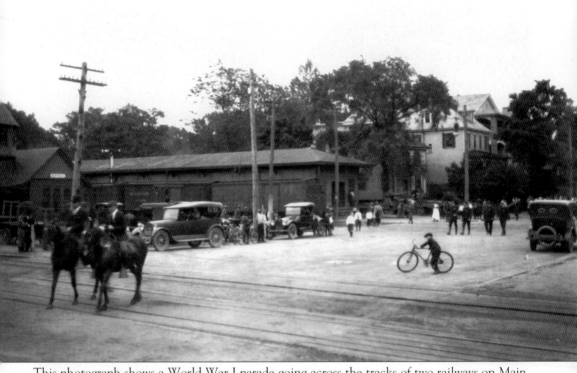

This photograph shows a World War I parade going across the tracks of two railways on Main Street. The far rails, where the marchers are passing, is the Seaboard Railroad. The riders on horseback are crossing the Virginian Railway. The Seaboard depot for passengers is located at the left and the freight depot is in the center of the picture. The third building to the right of the freight depot was Rawls Apartments, which became Main Street Apartments. In 1835, the Seaboard Air Line Railroad was the first to carry passengers and freight from Portsmouth, Virginia to Weldon, North Carolina, passing through Suffolk. (Courtesy of the Suffolk-Nansemond Historical Society.)

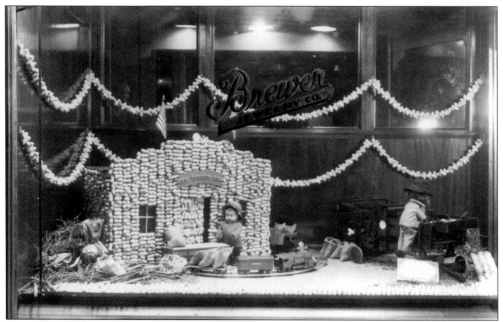

A display in the window of Brewer Jewelry Co., in February 1941, shows their support for the celebrations during the various events commemorating the peanut industry. Brewer Jewelry was established in 1878 after Richard L. Brewer purchased an existing business owned by Thomas W. Hannaford. Brewer was mayor of Suffolk in the mid-1850s. His son, R.L. Brewer Jr., who was also mayor in the early 1900s, became a partner in 1902. In 1924 the store was sold to Floyd A. Turner of Suffolk. (Courtesy of the Suffolk-Nansemond Historical Society.)

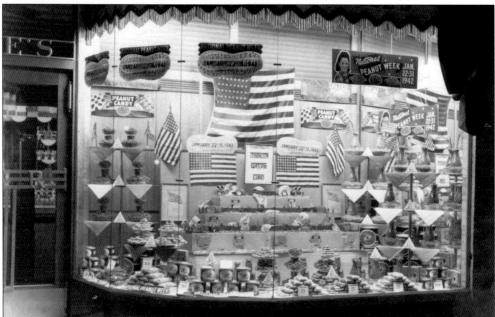

Roses 5-10-25¢ Stores, Inc. displays peanut designs in a window celebrating the Peanut Festival in the first half of 1942. The store was opened in the spring of 1929 in downtown Suffolk and it survived for well over 40 years. (Courtesy of the Suffolk-Nansemond Historical Society.)

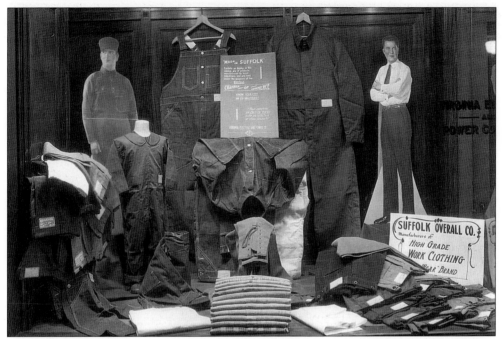

The Suffolk Overall Co. was located on Newport Street and owned by Joshua Cottingham West, who was a prominent businessman in Suffolk. They produced, according to their display, "High Grade Work Clothing." A sign in the window shows an endorsement by the Virginia Electric and Power Company. (Courtesy of Elizabeth B. Joyner.)

At Lake Kilby, the Portsmouth Waterworks was built to supply water for Suffolk and nearby Portsmouth. The lake was purchased in 1885 to begin the water pumping process and a small pumping station was built. The pumping station, shown in February of 1940, is located on Holland Road and continues to supply water to the community today. (Courtesy of the State Library of Virginia.)

R.N. Baker Jr. moved the Baker Funeral Home to this address at 509 West Washington Street in 1942. In 1885, Robert W. Baker came to Suffolk from Gates County, North Carolina and established his furniture store, R.W. Baker and Company, at 103 East Washington Street. The company remained there until 1915 when it moved to 208 West Washington Street where the business flourished. In 1925, Baker Funeral Home was opened at 115 North Saratoga Street and remained there until the move to West Washington Street. The businesses have been owned and operated by the descendants of R.W. Baker since the establishment of the company in 1885. (Courtesy of the State Library of Virginia.)

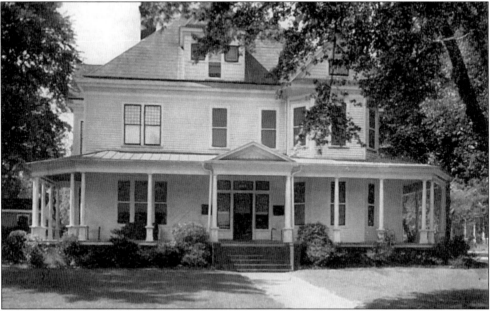

I.O. Hill Funeral Home was located at 447 West Washington Street. I. Owen Hill established I.O. Hill and Co. as a furniture store in 1891 and turned it into a funeral home five years later. The business was originally located at 215 West Washington Street and moved to 159 West Washington Street in 1896. (Courtesy of the Marion J. Watson Collection.)

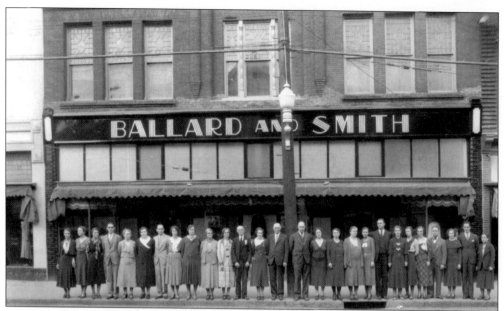

The employees of Ballard and Smith, Inc. are pictured in front of their building. It was a department store established in 1880 by Walter Wood Ballard and Otis S. Smith. Ballard and Smith was the leading store in the area to shop for fine goods for many years. Dry goods, notions, carpet, clothes, and rugs were among the items available at the store. The store was located on West Washington Street in the center of downtown Suffolk. (Courtesy of the State Library of Virginia.)

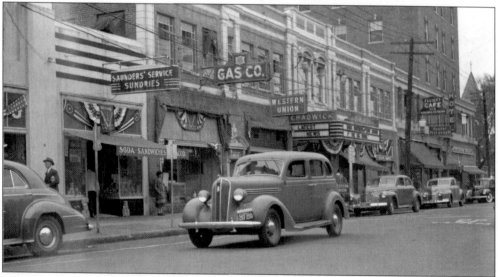

Here is a view of Main Street taken around 1941. Saunders Services Sundries, which carried sodas, sandwiches, and tobacco, is pictured on the left. The Suffolk Gas Company is on the right. Beside the gas company is the Western Union office where bicycles wait out front for their telegram-delivery drivers. The Chadwick is showing a Marx Brothers movie and newsreels of the day. The Gift Box is to the right of the Chadwick. The Elliott Hotel is on the corner and houses the Elliott Café known for serving "old Virginia cooking." (Courtesy of the Suffolk Nansemond Historical Society.)

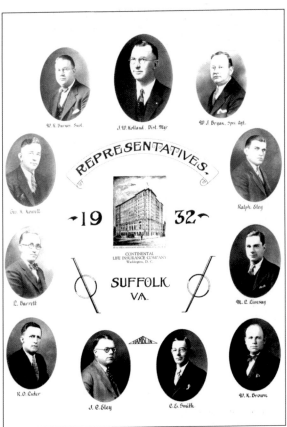

The Continental Insurance Co. had Hamlin Studio produce a picture of their organization in 1932 showing their local employees. The insurance company, based in Washington, D.C., served the community for many years. The employees, from left to right, are (first row) R.O. Luter, J.C. Eley, C.E. Smith, and W.H. Brown; (second row) L. Barrett and M. L. Livesay; (third row) George H. Howell and Ralph Eley; (fourth row) W.K. Barnes (superintendent), J. W. Holland (district manager), and W.L. Bryan (special agent). (Courtesy of the State Library of Virginia.)

Representatives from Building Inspection and Zoning for Nansemond are pictured here in 1968 reviewing electrical code information. They are, from left to right, Edwin T. Johnston, Tom Underwood, and Norman "Jack" R. Mathews. (Courtesy of the Suffolk-Nansemond Historical Society.)

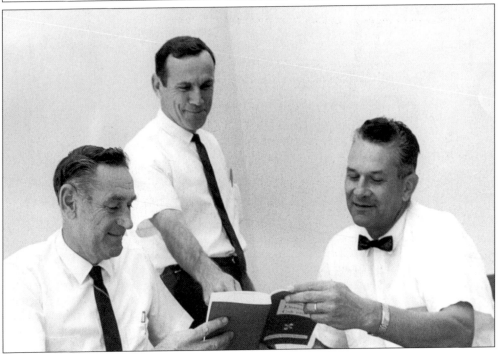

Two

FRIENDS AND NEIGHBORS

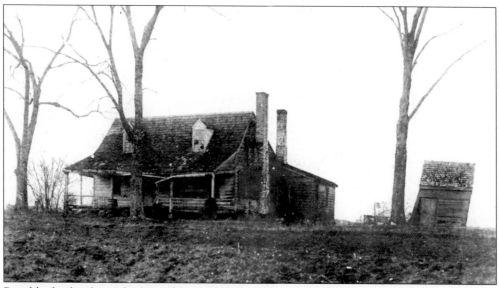

Possibly the first house built in what would become the town of Suffolk was constructed by John Constant and was named "Constantia." It was located in the area that is Cedar Hill Cemetery today. In 1720, John Constant built a warehouse on the south bank of the Nansemond River. Constantia was torn down in the early 1930s to make way for the cemetery. The Constantia Chapter of the Daughters of the American Revolution worked to have a replica of the house built in the cemetery. They used the house for meetings and as a chapel. The replica was later moved behind bakers Funeral Home. The move took over a year and was completed in 1994. (Courtesy of the State Library of Virginia.)

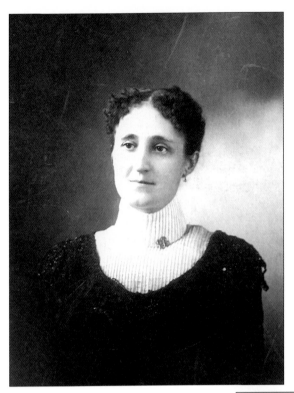

Annie Riddick Norfleet Ballard was the wife of Walter Wood Ballard, one of the founders of Ballard and Smith. She was born in 1860 and died in 1948. She was the daughter of Elisha Norfleet and his wife Sara Elizabeth Riddick. In later life she lived in an apartment on Main Street. (Courtesy of the Elizabeth B. Joyner collection.)

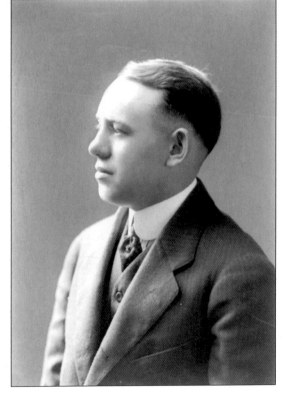

Moody Stallings Sr., pictured here in 1920, was a prominent attorney in the city. He was born in 1893 and received his law degree from Washington and Lee College. He served as mayor for Suffolk from 1915 until 1919. He was the youngest person to hold that office and acquired the nickname "The Boy Mayor." He died in 1920. (Courtesy of the State Library of Virginia.)

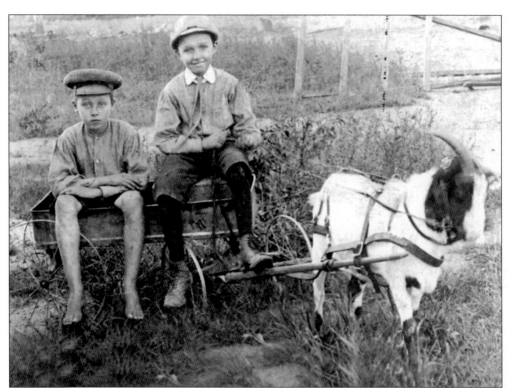

Two boys, probably on their way to find odd jobs, use the family goat to pull their wagon. This picture was taken in 1920. (Courtesy of the State Library of Virginia.)

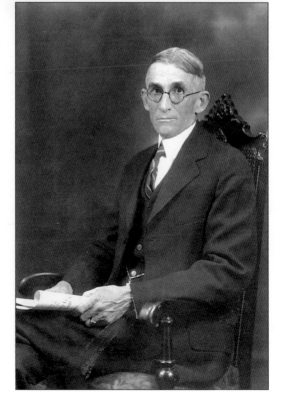

James L. McLemore came to Suffolk in the late 1800s to practice law. He became the judge of the circuit court of the Second Judicial District in 1907. He was also on the special court of appeals of Virginia. He was married to Mary Pretlow McLemore and lived on Pinner Street. He was a member of the Main Street Methodist Church and taught the men's bible class for many years. (Courtesy of Elizabeth B. Joyner.)

This picture, taken in 1965, is of A. Dupree Breeden, who was a well-respected architect in the area. He had a very successful career designing a number of diverse properties. Some of his designs included the West End Baptist Church, Birdsong Recreation Center, the Coca-Cola Bottling Plant, and the Chadwick Theater, as well as private homes. (Courtesy of the Suffolk-Nansemond Historical Society.)

Tommy Cooke was an undertaker in the city and had a successful business from the time he opened his funeral home in 1923 until his death in the early 1960s. He was married to Lessie Cooke. The T.E. Cooke Funeral Home (now T.E. Cooke-Overton Funeral Home) is still located at its original site on 405 Johnson Avenue. (Courtesy of the State Library of Virginia.)

Margery Palmer was one of the first librarians of the Morgan Memorial Library located on Bosley Avenue. She worked at the library from 1959 until 1976. She was married to T.O. Palmer who worked first for the Virginia State Highway Department and then the Veteran's Administration from which he retired. (Courtesy of the Suffolk-Nansemond Historical Society.)

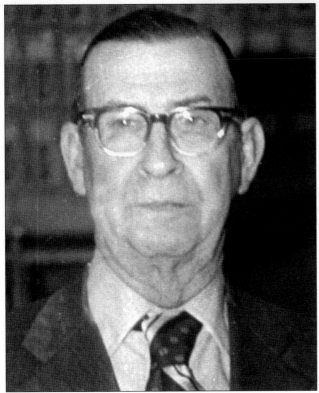

John Henry Powell, born in Nansemond County in 1908, graduated from the University of Richmond with a degree in law and began his practice in Suffolk. His father, Paul J. Powell, was the clerk of Nansemond County courts. When the elder Powell died in 1930, John Henry took over as clerk of the court. He held that position until he retired on December 31, 1973 as the last clerk of Nansemond County when Nansemond was merged with Suffolk. He died in 1985. (Courtesy of the Suffolk-Nansemond Historical Society.)

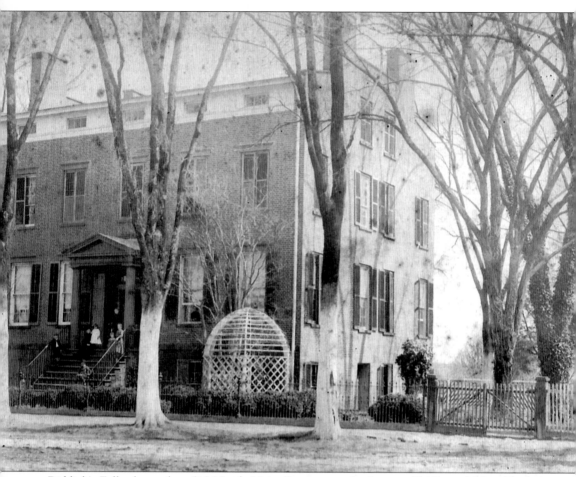

Riddick's Folly, located at 510 North Main Street, was the home of Mills and Mary Taylor Riddick. Mills Riddick played an important part in the development of Suffolk. He had a number of business and farm interests in the community and represented Suffolk and Nansemond County in the Virginia House of Delegates in the early 1800s. The residence was finished in 1839 on the same ground where his first house stood before it burned on June 3, 1837. Pictured on the porch of the residence are two of Mills and Mary Taylor Riddick's granddaughters, Anna Mary Riddick and Missouri Taylor Riddick Withers. Also pictured are their great-grandchildren, Nathaniel Riddick Withers, Missouri Kilby Withers, Janet Alexander Withers, John Thornton Withers, Robert Walter Withers, and Anna Chinn Withers. (Courtesy of Riddick's Folly, Inc.)

Anna Mary Riddick was a prominent figure in Suffolk. Born July 21, 1841, she never married and was a very independent woman. She was the first woman in the city to vote and was a charter member and the first president of chapter #173 of the United Daughters of the Confederacy. She served in that capacity for 30 years. She was able to join due to the service of her two brothers Mills and John T. Riddick. She lived in the same house she was born in until her death in 1936. (Courtesy of Riddick's Folly, Inc.)

Mr. William Simpson Beamon was president of Beamon's Inc., a building supply company. He started the business with his partner, Herbert H. Holland in 1900. The business began as the Holland and Beamon Company and in 1948 became Beamon's Inc. The company was located at 801 East Washington Street and the Norfolk and Western Railroad. Their business covered parts of Virginia and North Carolina supplying coal, hay, grain, plaster, lime, cement, and fertilizers. Beamon was a charter member and past president of the Suffolk Rotary Club, past exalted ruler of the Suffolk Elks Club, and a member of the Masonic Lodge. He was on the board of directors for the Farmers Bank of Suffolk and held positions on the Suffolk school board and city council. His parents were Dr. John Richard Beamon Jr. and Alida Norfleet Beamon who lived in Nansemond County. He was a member of the Suffolk Christian Church and served as superintendent of the Sunday school for over 40 years. He was a driving force in the building of the educational building of the church. (Courtesy of Elizabeth B. Joyner.)

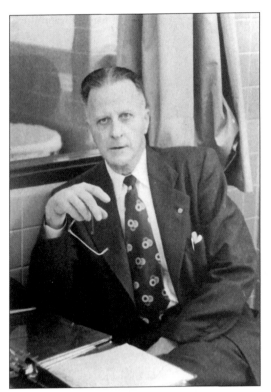

George Richardson Joyner Sr., a local pediatrician, was born, raised, and lived in Suffolk until his death in 1970. He was the son of Mathew W. and Nannie Holman Joyner. He attended Jefferson High School and graduated with a degree in medicine from the University of Maryland. Dr. Joyner was married to the former Lucile Bowie. He practiced in Suffolk and in World War II served as a lieutenant colonel in the United States Army Medical Corps in Battle Creek, Michigan. He was the first president of the Obici hospital staff and the first president of the Suffolk Kiwanis Club. He was a member of the American Legion, Suffolk Masonic Lodge, Suffolk Chamber of Commerce, and a charter member of the Suffolk Nansemond Historical Society. He also served for many years as the coroner for Nansemond County. (Courtesy of the Marion J. Watson Collection.)

James McLemore Jr., was born in 1912 and lived in Suffolk most of his life. He attended Randolph Macon College and received a degree from the T.C. Williams School of Law. He began his practice of law in 1938. In 1958, he joined the National Bank of Suffolk, which his father, James L. McLemore Sr., helped organize. He continued his practice until his retirement. He is married to Jane Coulbourn McLemore. (Courtesy of Elizabeth B. Joyner.)

A 10-year-old Marion Watson is pictured here in a nurse outfit her mother made for Halloween in the late 1930s. She had matching dolls to go with her outfit and competed in a contest for best costume. She was the daughter of G.R. Joyner and Lucile B. Joyner. (Courtesy of the Marion J. Watson Collection.)

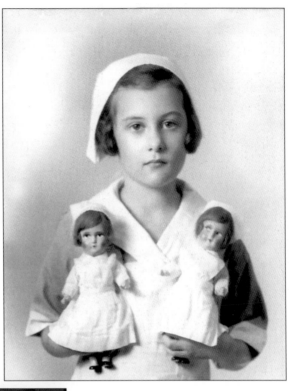

Marion J. Watson grew up and lived most of her life in Suffolk. She was very active as a charter member of the Suffolk Nansemond Historical Society and held several other positions over the years. For almost 30 years, she served as historian for the society as well as unofficial historian for the city. She helped create a number of publications for the historical society and was a resource to residents and visitors in tracing their ancestors. For 23 years, she was an examiner for the Virginia Department of Motor Vehicles in Suffolk, where she retired. She was a member of St. Paul's Episcopal Church and worked in the latter part of her life organizing the records and photographs that tell the history of the church. She lived until her death at her family home, Gray Gables, on Bennett's Creek in Suffolk. (Courtesy of the Marion J. Watson Collection.)

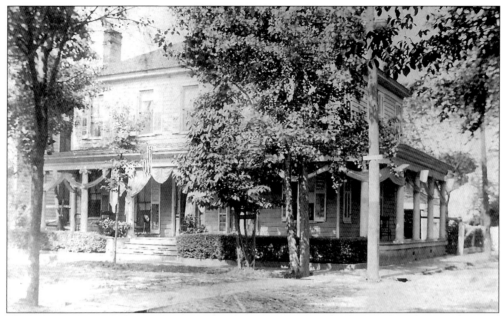

The Joyner House was located at 133 Chestnut Street. It was the home of Mathew Walter and Nannie Thornton Holman Joyner. The house was decorated for Fourth of July Celebrations in the early 1900s. His son, Dr. G.R. Joyner Sr., and his wife, Lucile Bowie Joyner, later occupied the home. The house was torn down in the early 1970s. (Courtesy of the Marion J. Watson Collection.)

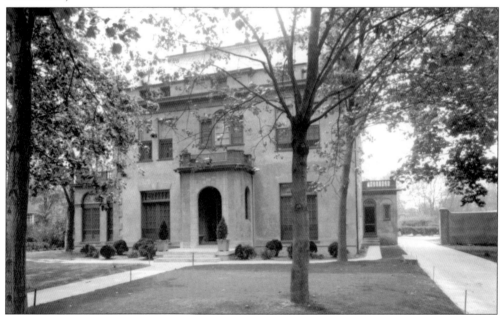

This was the residence of the Pinner family. John F. Pinner and his wife, Katherine, lived here for many years. He was the son of John B. Pinner, who was the founder of the Suffolk Peanut Company and a pioneer in the development of peanut production in the Suffolk area. John F. Pinner served as president of Suffolk Peanut Company after his father's death in 1938, until his own death in 1957. (Courtesy of the State Library of Virginia.)

Dorothy Batten Kitchin was a longtime resident of Suffolk. She lived on Oakdale Terrace and for many years was a schoolteacher at George Mason Elementary School. She was married to William Willis Kitchin Sr. She and her sisters helped the war effort during World War I by traveling to the munitions plant in Yorktown to work. This picture was taken in 1920. (Courtesy of the State Library of Virginia.)

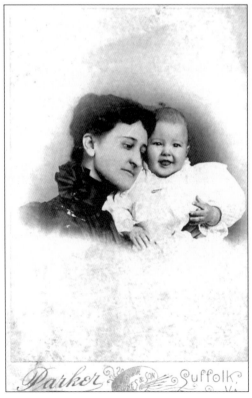

Nannie Joyner holds her first-born child, Mathew Walter Joyner Jr. in the late 1800s. He lived for only 18 months. Her second son, G.R. Joyner Sr., was born several years later. Mrs. Joyner was the daughter of John Seymour Holman and Anne Lavinia Holman and grew up in Farmville, Virginia. She was a member of the Presbyterian Church in Suffolk and was killed in an automobile accident near Driver, Virginia on April 21, 1929. (Courtesy of the Marion J. Watson Collection.)

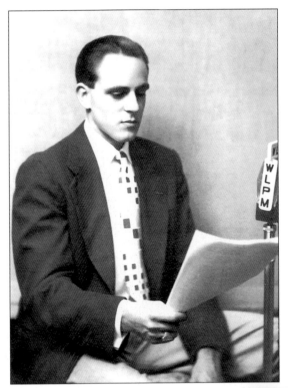

Fredrick Lee Hart Jr. was raised in Suffolk and became a prominent businessman. He was the son of Fredrick Lee Hart Sr. and Hannah M. Dawson Hart who lived on Brewer Avenue. He graduated from high school and attended VMI but came home to help his father in the family business, Nansemond Drugstore. He later became founder and president of WLPM Radio Station in Suffolk. The call letters, WLPM, stood for World's Largest Peanut Market. He was head of the Boy Scout Council and at one time, president of the Rotary Club. He was also a director of the National Bank of Suffolk. He was married to Margaret Maxine Simpson Hart from North Carolina and they lived on Riverview Drive. (Courtesy of the Marion J. Watson Collection.)

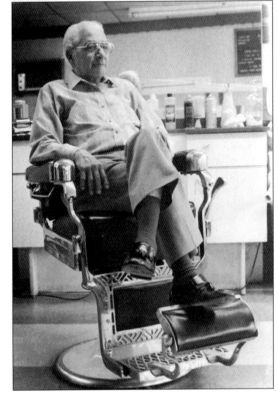

Louis Vincent DeMarco was a barber for 60 years. He came to Suffolk in 1958 and decided to stay and set up his business. He continued to work well into his 80s. (Courtesy of the Suffolk-Nansemond Historical Society.)

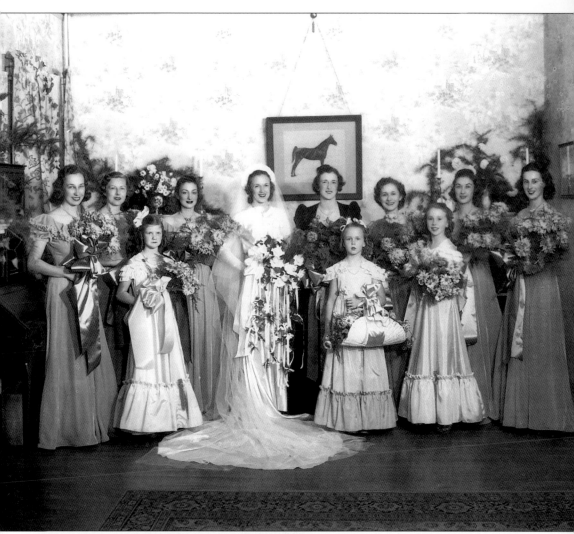

The wedding of Virginia Reed West to William Harrell Reid took place on December 12, 1940 at Oxford Methodist Church. Rev. W.W. Staley presided. The reception was held at the home of the bride's parents, Mr. and Mrs. Joshua Cunningham West Jr. Members of the wedding party, from left to right, are (front row) Elizabeth West Birdsong Joyner, Martha Crocker Spivey, and Sara Crocker Hobbs; (back row) Marguerite Bell, Frances Hutchins West, Mary Cross Jordan, Virginia Reed West Reid, Katherine West Crocker, Margaret Hutton, Jerry Burger, and Polly Pinner. (Courtesy of Mrs. Elizabeth B. Joyner.)

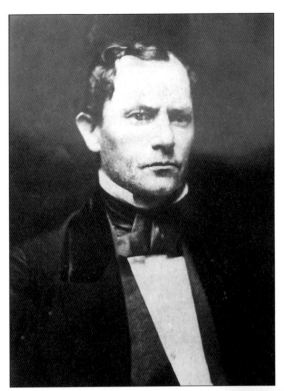

Robert Riddick Prentis Sr. was born in Suffolk in 1818. He practiced law until 1853 and then became the proctor for the University of Virginia. He was also the clerk of Albemarle County, Virginia and the collector of internal revenue for the Confederacy during the civil war. (Courtesy of the Marion J. Watson Collection.)

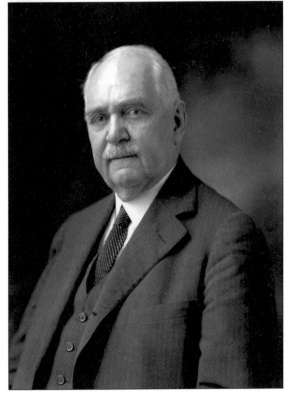

Robert Riddick Prentis Jr. was born in Charlottesville, Virginia in 1855. In 1880, after receiving his law degree in one session from the University of Virginia, he came to his father's hometown to practice law. He was appointed the position of associate justice from 1916 until 1925, and then became chief justice of the state supreme court of appeals until his death in 1931. This picture was taken on July 3, 1947. (Courtesy of the State Library of Virginia.)

Carrie W. Owens is pictured here with her five-month-old son, Marion Richardson Owens. She worked as a nanny and lived most of her life in Suffolk. (Courtesy of the Marion J. Watson Collection.)

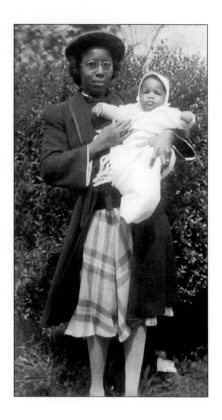

Henry Buff Norfleet is decked out in his finest attire for this picture. He was the son of John B. and Amelia Buff Norfleet. He was born in 1897 and died in 1967. His family attended St. Paul's Episcopal Church. (Courtesy of St. Paul's Episcopal Church.)

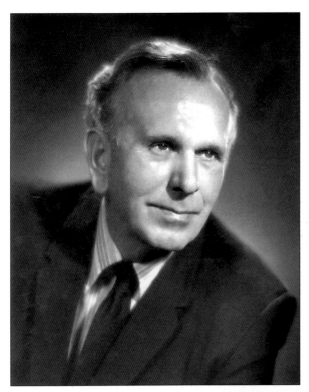

William Elmer Austin Moore moved with his family to Suffolk as a teenager. His father worked for the railroad and his mother worked for the Suffolk Health Department. He attended the College of William and Mary, settled in Suffolk, and purchased Hamlin Photographic Studio. He was married to Margaret Hewlett Moore. Billy Moore was a past president of the Virginia Photographers Association, a member of the American Legion, and served on the vestry of St. Paul's Episcopal Church. (Courtesy of Martha Moore Turner.)

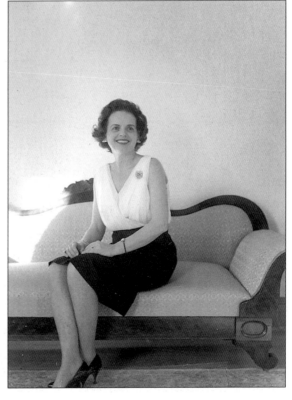

Margaret Hewlett Moore and Billy Moore lives on Broad Street. Mrs. Moore came to Suffolk to teach in the Suffolk school system and taught for several years at Suffolk High School. She was in charge of the glee club, participated in the Daughters of the American Revolution, was a member of the Riverview Garden Club, and serves in the choir at St. Paul's Episcopal Church for many years. (Courtesy of Martha Moore Turner.)

Maj. Mathew Walter Joyner sold wholesale goods and resided at 133 Chestnut Street with his wife Nannie Thornton Holman Joyner. They were married in 1891 and had two sons. He was active in the community and was a charter member of the Suffolk Chamber of Commerce, the Knights of Pythias, the Royal Arch Masons, and the Suffolk Christian Church. He received the title of major when he was commissioned as an officer of the Suffolk Home Guard during World War I. In this picture he is wearing his home guard uniform. (Courtesy of the Marion J. Watson Collection.)

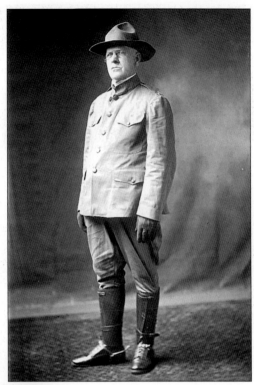

Mr. and Mrs. Marion Kendrick, surrounded by their children, are dressed up to take a family portrait in the 1930s. They were members of St. Paul's Episcopal Church. (Courtesy of St. Paul's Episcopal Church.)

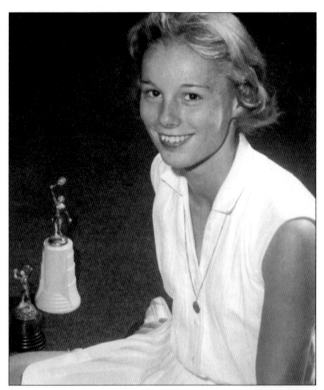

Tennis was a popular sport for residents as well as local school children. Barbara Barrett Brantley was an avid tennis player in Suffolk and won the 1957 Virginia Junior Women's Championship. (Courtesy of the Suffolk-Nansemond Historical Society.)

Major Benton was a local businessman in Suffolk who owned a sign painting company. He served as mayor of Suffolk from 1961 until 1965. He was married to Lillian Smithers Benton. (Courtesy of the State Library of Virginia.)

Virginia Lee Goode, a resident of Suffolk, won the *Glamour Magazine* "1954: 10 Girls with Taste Survey." Virginia enjoyed a career as a model for several years and appeared on the covers of several popular magazines. She was the sister of John and Robert Goode. (Courtesy of the Suffolk-Nansemond Historical Society.)

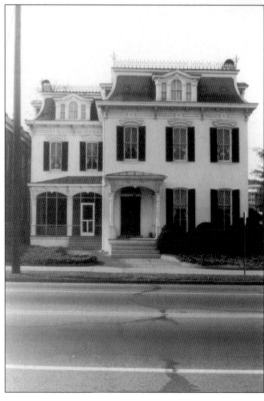

This is a photo of the original home of Richard Seth Eley and his wife Eliza Pricilla Riddick Eley, located at 251 North Main Street. They built the home in 1878 on property owned by Mrs. Eley's father, Benjamin Riddick. Riddick was mayor of Suffolk from 1861–1862 and again from 1875–1889. He was the last mayor before Union troops took over Suffolk during the Civil War. Several generations of the Eley family have occupied the house. (Courtesy of the Suffolk-Nansemond Historical Society.)

James K. Hutton was born in 1888. He received his law degree from Richmond College, later the University of Richmond. He was in private practice in Suffolk when he was appointed judge of the Second Judicial Circuit Court in 1907 and held this position for 33 years. He died in 1954. (Courtesy of the Suffolk-Nansemond Historical Society.)

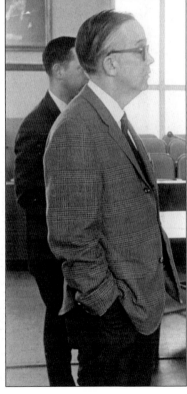

Joshua Pretlow Sr. was born in Appomattox, Virginia in 1919. He attended Virginia Polytechnic Institute and State University, studied for the bar exam, and passed in 1948. He had a law practice in Suffolk for many years. He held the position of Commonwealth's Attorney for both Suffolk and Nansemond County from 1969 until 1974 when he passed away. (Courtesy of the Suffolk-Nansemond Historical Society.)

Ira Estes "Spike" Moore served for many years as a photographer for the *Suffolk News Herald*. He also served as managing editor for a time. He moved to Suffolk with his family as a youth. He attended the College of William and Mary before beginning a newspaper career with the newspaper that would last for most of his life. (Courtesy of Martha Moore Turner.)

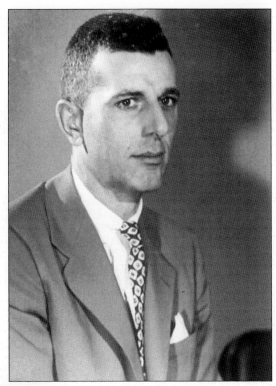

Celebrating their 25th wedding anniversary are Thomas Henry Birdsong and his wife, Martha McLemore Birdsong. He was president of Birdsong Peanut Company. She was the sister of Judge McLemore. (Courtesy of Elizabeth B. Joyner.)

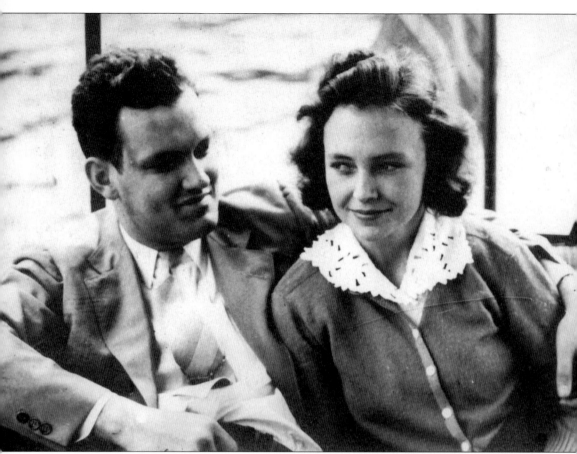

Mills E. Godwin Jr. and his wife, Katherine Beale Godwin, lounge aboard a yacht in Hampton in the summer of 1939 before their marriage. Mills Godwin, from Chuckatuck, had a very successful political career in Virginia. He was born in Chuckatuck in 1914. He attended the College of William and Mary and the University of Virginia Law School. His political career began when he was elected to the Virginia House of Delegates in 1948. He held elected offices in the Virginia State Senate, as lieutenant governor, and as governor of Virginia twice. During his first term (1966–1970), he served as a Democrat. The second time he was elected he was a Republican and held office from 1974 to 1978. The Godwins had a daughter named becky. She was fatally injured by lightning at Virginia Beach in August 1968. Mills Godwin retired to Suffolk and lived there until his death in 1999. Katherine Beale Godwin is the daughter of Fenton Parker and Dilla Bradshaw Beale. (Courtesy of Riddick's Folly, Inc.)

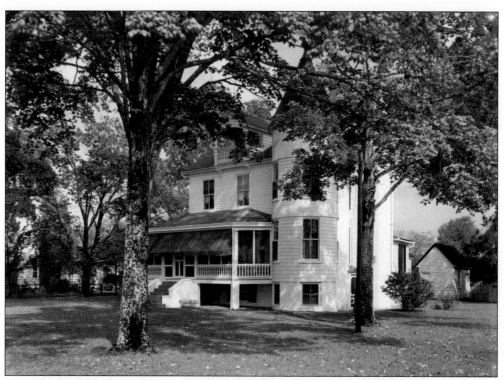

Gov. Mills Godwin's childhood home was located in Chuckatuck, Virginia. He lived there with his parents, Mills Edward Godwin Sr. and Otelia Darden Godwin. He attended the local schools before going to college. (Courtesy of Riddick's Folly, Inc.)

Mills E. Godwin, Sr. was an active member of the Chuckatuck Ruritans Club and was involved in civic duty until his death in 1946. (Courtesy of Riddick's Folly, Inc.)

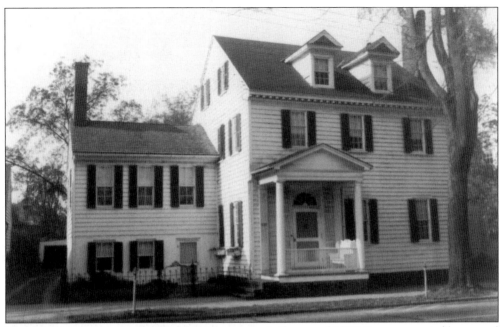

This home, located at 227 North Main Street, was built around 1800. It was occupied by several generations of the Riddick family. Archibald Riddick owned the house and left it to his son, Benjamin Riddick, who was the mayor. During the Union occupation of his offices, Benjamin Riddick used the addition on the south side of the property as his office. (Courtesy of the Suffolk-Nansemond Historical Society.)

Harvard Birdsong played a vital part in the development of Suffolk as the leader in the peanut industry. He worked at Birdsong Storage Co., a peanut shelling operation, and helped that company grow and expand over the years. He was a founding member of the National Peanut Administrative Committee as well as holding the position of president of the Virginia-Carolina Peanut Association in the 1950s. He served as a director of the National Peanut Council as well. He spent most of his life in Suffolk, having moved there at the age of two with his family. He was also involved in the banking community and served on the boards of the Old Farmers Bank of Nansemond, Seaboard Citizens National Bank, and United Virginia Bank. He helped improve education in the area by serving on the Suffolk School Board in the 1940s and as a director of the Virginia Foundation of Independent Colleges in the 1950s. He was married to Mary Taylor Withers Birdsong. (Courtesy of Elizabeth B. Joyner.)

Archibald Riddick originally built this structure for his son, Benjamin Riddick, to use as an office. It began as a one-story building with a fireplace and small windows. In 1857, the building was purchased by Mrs. David B. James and then renovated. Theodore Myrick, commissioner of revenues for Suffolk, owned it in later years. (Courtesy of the Suffolk-Nansemond Historical Society.)

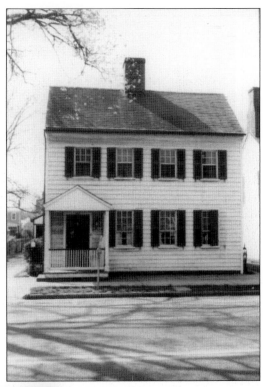

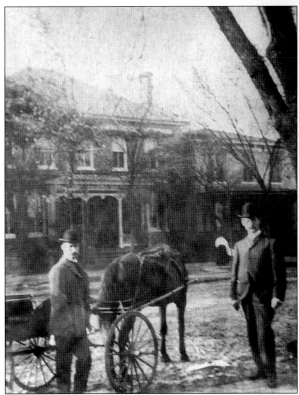

John B. and Robert J. Norfleet, twins, were veteran real estate men and leading citizens of Suffolk. Born October 13, 1866, they started in the hardware business before moving to real estate. John was mayor of Suffolk for four years from 1907 to 1911. He was also police justice and served as postmaster during Woodrow Wilson's presidency. Robert served on the Suffolk School Board for a time but left politics to his brother. They are pictured in front of the Christian Church Parsonage on Main Street. (Courtesy of Elizabeth B. Joyner.)

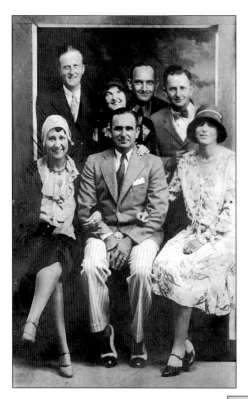

Several friends got together and had their picture taken for a postcard, as was common in the 1920s and 1930s. From left to right are (front row) Lucile Bowie Joyner, Melvin Lovelace, and Mary Stott; (back row) Dr. George Richardson Joyner Sr., Madeline Lovelace, George Ben Stott, and Dr. Whitney Godwin. Melvin Lovelace worked for the city of Suffolk as commonwealth attorney, George Ben Stott worked for Planters Peanuts, and Dr. Whitney Godwin was a dentist and businessman. (Courtesy of the Marion J. Watson Collection.)

Joshua Cunningham West Jr. and his wife, Katherine Beamon West, celebrated their 45th wedding anniversary at the home of their daughter, Katherine West Crocker. West owned the Suffolk Overall Company. He was also chairman of the school board at one time. He and his wife lived at 518 West Washington Street. (Courtesy of Elizabeth B. Joyner.)

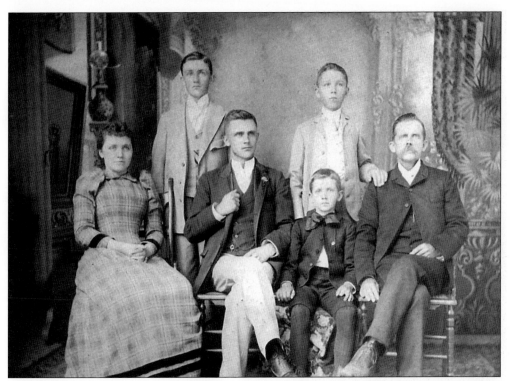

The Birdsong family is represented by several generations in Suffolk. This picture shows members of the earliest generation. Pictured here from left to right are (front row) Nannie Birdsong, Thomas Henry Birdsong, Silas Birdsong, and Sydney Algenon Birdsong; (back row) Frank Birdsong and Rosser Birdsong. This photograph was taken between 1875 and 1880. (Courtesy of Elizabeth B. Joyner.)

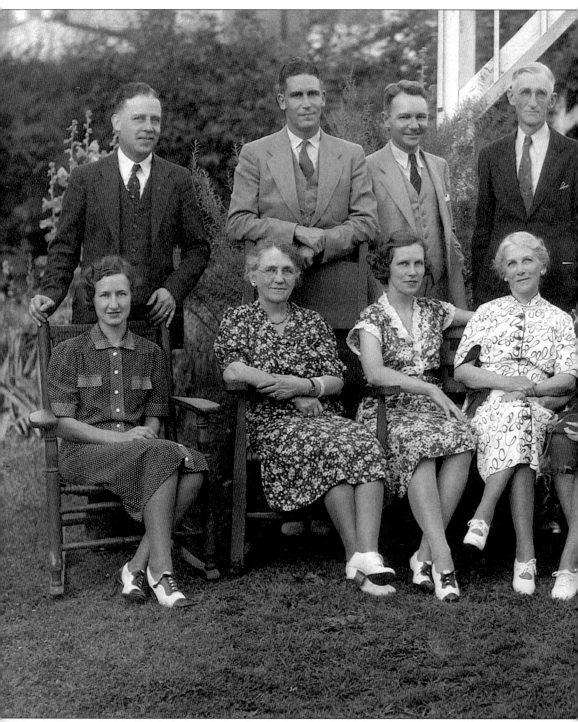

The Birdsong family played an integral part in the growth and development of Suffolk. They established Birdsong Peanut Corporation and several Birdsongs were prominent doctors and lawyers. Family members, from left to right, are (front row) Yancey Brooking Birdsong, Nancy Birdsong, Frances Birdsong Darden, Martha McLemore Birdsong, Helen Birdsong Macklin,

Elizabeth West Birdsong, Mary Taylor Withers Birdsong, and Virginia Wishard Birdsong; (back row) William McLemore Birdsong, Dr. McLemore Birdsong, Austin Taylor Darden, James L. McLemore, Harold H. Macklin, Hall F. Birdsong, Harvard Russell Birdsong, and Thomas Henry Birdsong Jr. (Courtesy of Elizabeth B. Joyner.)

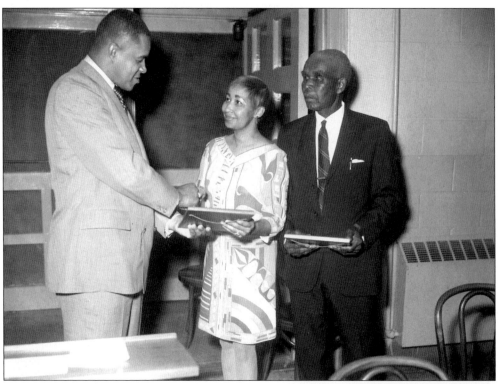

Dr. Margaret Reid was a prominent physician in Suffolk who won a number of awards over the years. She traveled extensively with her husband, Dr. L.T. Reid, and had an exquisite collection of African art. She is pictured here receiving an award at a NAACP meeting on May 19, 1970. (Courtesy of the State Library of Virginia.)

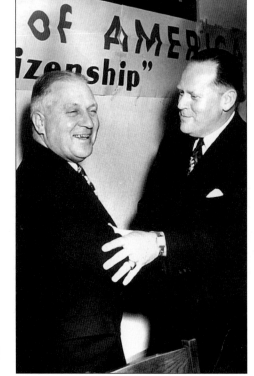

Fred Hart, president of the local radio station, WLPM, congratulates Tom Birdsong on becoming First Citizen of Suffolk and Nansemond County in 1957. He served as chairman of the City Planning Commission, a past president of the Chamber of Commerce, and was active in the Lion's Club. (Courtesy of Elizabeth B. Joyner.)

Lucile Bowie Joyner was the wife of Dr. G.R. Joyner Sr. She came to Suffolk as a bride after attending and graduating from the University of Maryland Nursing School. She was an active member of St. Paul's Episcopal Church. She served on the Woman's Auxiliary of Obici Hospital, was a charter sponsor in the Junior Volunteer Service Corp., and a member of the Suffolk Woman's Club and Social Club. She was the daughter of John Chrisman Bowie and Frances Fendall Bowie. (Courtesy of the Marion J. Watson Collection.)

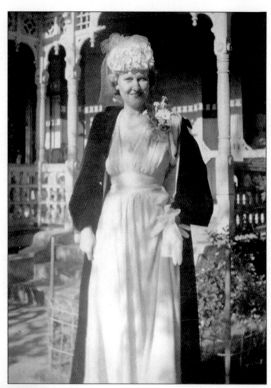

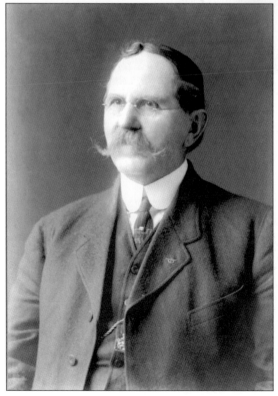

John King was a leading businessman in Suffolk. He first partnered with John Pinner to form the Suffolk Peanut Company in 1897, which became the first successful peanut company. He created the John King Peanut Company in 1909 and incorporated in September of 1910. It consisted of two large buildings and they served as cleaners, graders, shellers, and wholesale dealers for the peanut farmers in the area. They specialized in Virginia and Spanish peanuts. (Courtesy of the State Library of Virginia.)

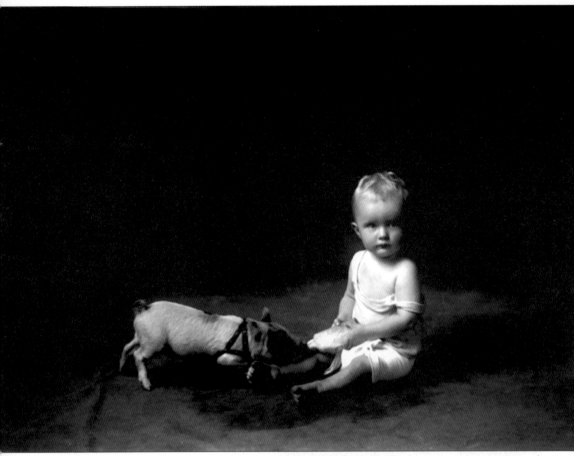

Fred Hamlin was a very successful photographer in Suffolk and had a business spanning several decades. He not only took portrait pictures of Suffolk's citizens but also captured many historical activities. His main business was taking portraits in his studio. Here is an example of one of his photos of a child with a pet pig. His pictures could be very unique at times. (Courtesy of the State Library of Virginia.)

Three

HOUSES OF WORSHIP

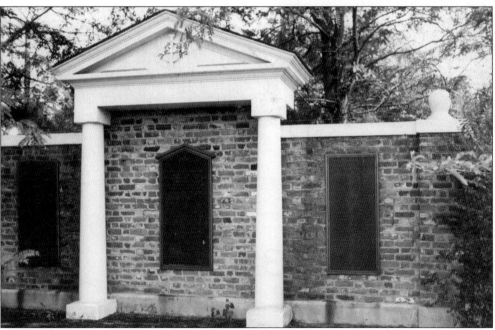

The memorial to the First Colonial Church in Suffolk is located behind the main post office on Western Avenue near the site of the first church. The first church was built *c.* 1753 and was used through the late 1800s. Over the years the church was neglected and was in great need of repair. Attempts were made to raise funds with no success. The church was eventually razed. The Association for Preservation of Antiquities built the monument in 1933. Tablets were placed on the wall with the names of the colonial governor, ministers of the upper parish, and members of the House of Burgesses from Nansemond County. (Courtesy of the Suffolk-Nansemond Historical Society.)

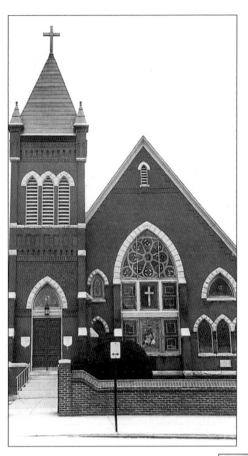

St. Paul's Parish began life as one of three colonial parishes of the Upper Parish of Nansemond County. The first church was built near Reid's Ferry, northeast of Suffolk. This church served the community from 1642 to 1753. Several items given to the church by Queen Anne of England survived. A new church was built in 1753 near the Nansemond River in town. This church served through the American Revolutionary War. After the war, the church fell into disrepair and stopped serving the community. By 1820 even the bricks of what was left of the church were sold. The money from that sale was used to buy a bell that would hang in the next church. The next church was located in the 300 block of North Main Street. Finally in 1895 the congregation found a permanent home. The church they built exists today on North Main Street. The church houses the sanctuary chairs and an altar cloth from the branch church at Reid's Ferry, the Bible from the church located near the Nansemond River, and the bell made from the sale of the bricks and the Sanctuary tablets from the previous church. The parish had a celebration in 1992 commemorating the 350th anniversary of its founding. Many present and past members attended. (Courtesy of St. Paul's Episcopal Church.)

Arthur L. Kenyon was the pastor of St. Paul's Episcopal Church on Main Street from 1922 until 1925. The church was built in 1895. Several additions to the church were made in 1914 and 1922. Kenyon oversaw the additions that were made to the church in 1922. The interior of the church was completely renovated with a new organ during 1966–1967. (Courtesy of St. Paul's Episcopal Church.)

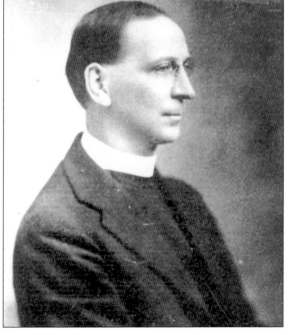

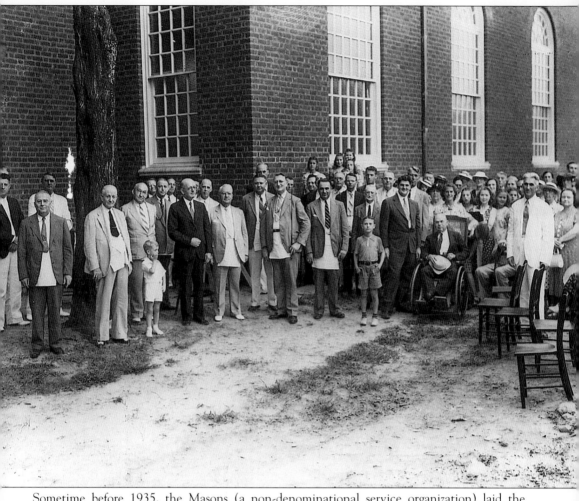

Sometime before 1935, the Masons (a non-denominational service organization) laid the cornerstone at the West End Baptist Church. The Masonic Lodge was made up of a group of men who were symbolically descendants of the ancient craft of stonemasons, who were builders of the great cathedrals and churches of the Middle Ages. The congregation of the church was there to witness the event. (Courtesy of the Suffolk-Nansemond Historical Society.)

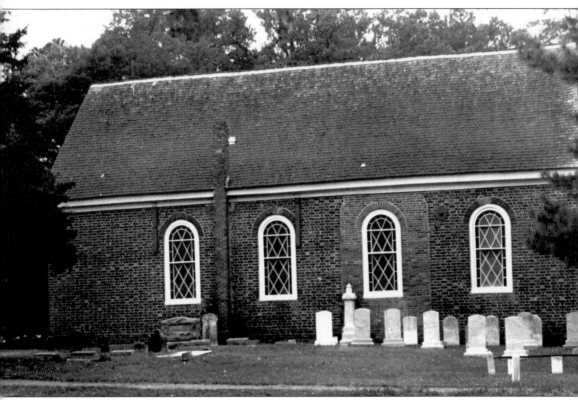

Glebe Episcopal Church, located in Driver, was built in 1737. It began functioning as Bennett's Creek Church but was later named after the colonial Glebe lands. In 1775, the congregation of the church expelled the minister, Parson Agnew, because he supported the British during the Revolutionary War. It fell into disrepair in the late 1700s and early 1800s, but was restored in the 1850s. After much renovating, Glebe Episcopal Church is still in operation today. (Courtesy of the Suffolk-Nansemond Historical Society.)

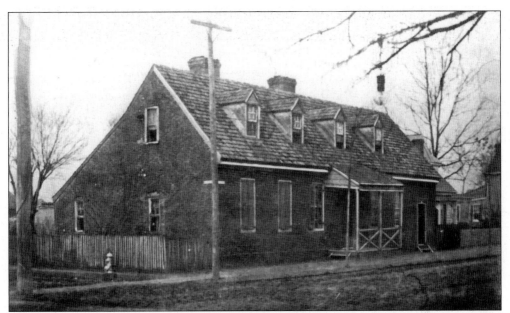

The Alms House, built in 1754, was a very important structure in the various roles that it played in history. It was intended to be a "free school for the poor" at the time of its birth but it ended up serving a variety of purposes. When the Union soldiers occupied Suffolk they used it to house prisoners. Its religious significance came when black churchgoers used it as the First Baptist Church in the late 1800s. (Courtesy of the Suffolk-Nansemond Historical Society.)

The Suffolk Christian Church located on Main Street was organized in 1859 by a group of worshippers in the home of Rev.William Brock Wellons. The funds were raised to build the church and it was ready to be occupied in March of 1860. It was unique in that the church was built before the congregation was completely formed. The church has had a number of renovations to bring it to completion. In 1882, Dr. William W. Staley became one of the driving forces in the church and served as the pastor or Pastor Emeritus for over 50 years. (Courtesy of the Suffolk-Nansemond Historical Society.)

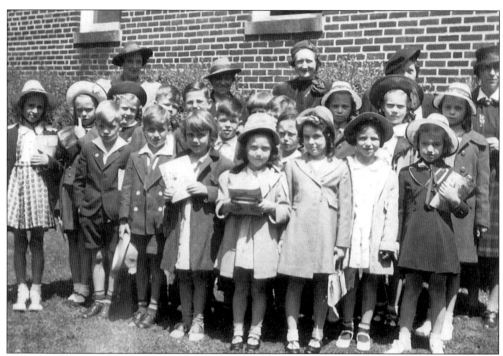

On a sunny Sunday morning in the early 1930s, this picture was taken of a group of Sunday school students at the Oxford Methodist Church. The church is located on West Washington Street. (Courtesy of Elizabeth B. Joyner.)

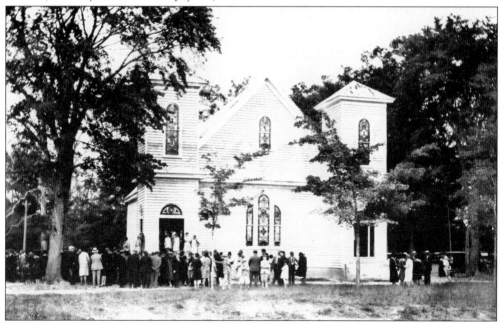

Western Branch Baptist Church was founded in 1779 and was the first Baptist church in Nansemond County. This was the third building on this site. The earlier building was burned by Union troops during the Civil War in 1863. The Scruggs's Mill Pond nearby was used for baptisms well into the 1950s. (Courtesy of the State Library of Virginia.)

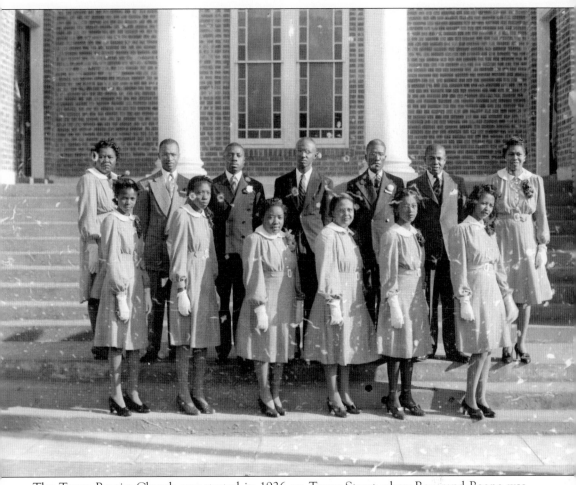

The Tynes Baptist Church was started in 1926 on Tynes Street when Reverend Boone was the pastor. In 1953 the church was burned out and moved to County Street. The name was changed in the early 1960s to the Metropolitan Baptist Church. A group of men and women ushers from the church are pictured here January 17, 1943. (Courtesy of the State Library of Virginia.)

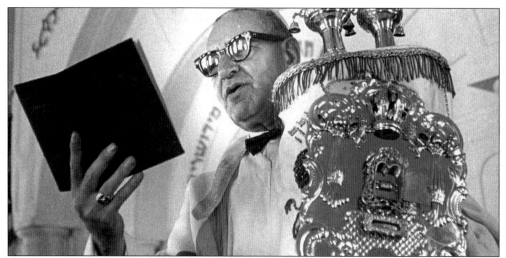

Dr. Murray Kantor was a well-respected member of the community as the rabbi for Agudath Achim congregation. He resided over the Jewish membership longer than any other rabbis in Suffolk. He served twice, the first time for four years and the last for nineteen years. He was the last rabbi to serve Suffolk because the congregation dwindled to just a few families. There are references to a Rabbi I. Yoffe in Suffolk in 1914. He was a grocer as well as a rabbi. One of the early meeting places for the group of devoted members was in the Masonic Temple. The group purchased an old Presbyterian Church on Bank Street in 1923. The synagogue itself flourished for a number of years, however, in the mid-1990s, because of a lack of participation, it was closed and all the belongings were given to the Congregation Beth EL in Norfolk, Virginia. (Courtesy of the Suffolk-Nansemond Historical Society.)

Milton Reid served as the pastor of the First Baptist Church at 112 Mahan Street in the mid-1900s. The fourth pastor at the church was Rev. William W. Gaines, who was there from 1891 to 1911. He was also the founder of the black school, Nansemond Collegiate Institute. (Courtesy of the State Library of Virginia.)

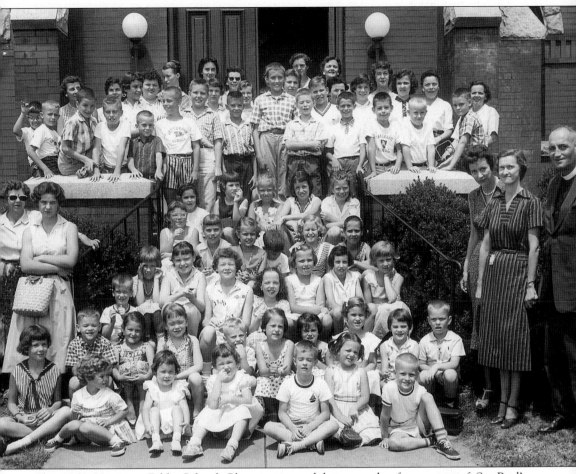

The 1959 Vacation Bible School Class is pictured here on the front steps of St. Paul's Episcopal Church. Vacation Bible School was an annual event to provide the children of the parish with some summer fun and activities to bring them closer to the church. Reverend Witchard is on the right and served as rector at St. Paul's for many years. (Courtesy of St. Paul's Episcopal Church.)

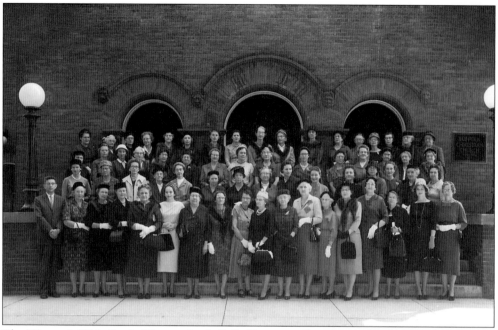

The Women's Bible Study Class at the Suffolk Christian Church was photographed in October of 1960. Many such groups existed at the church because it had such a large congregation. The Women's Bible Study program at the church began in 1913 and was the first one of its kind established in the Virginia Christian Conference. (Courtesy of the State Library of Virginia.)

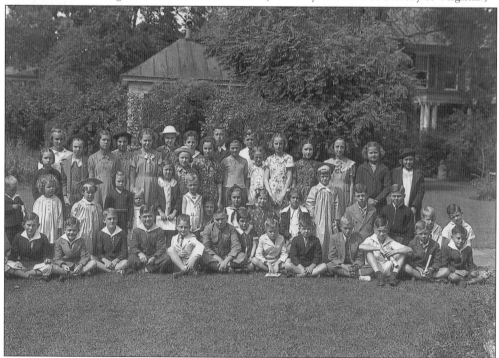

This picture was taken on a spring day, c. 1930, of Sunday School students of the West End Baptist Church. (Courtesy of the Suffolk-Nansemond County Historical Society.)

Four

EDUCATIONAL
FACILITIES

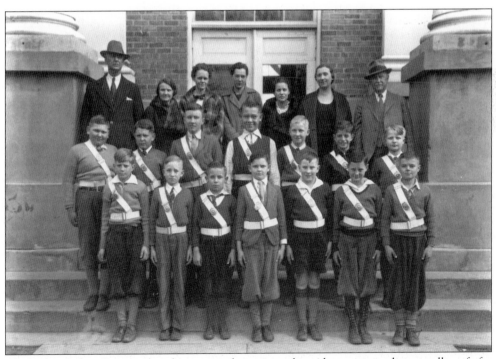

The Safety Police System played an integral part in making the streets and crosswalks safe for students. Pictured here are a number of the student safety patrol members and their sponsors at George Mason Elementary School. They are wearing the characteristic white belts across their chests to make them more visible to cars. This picture was taken in the 1930s. (Courtesy of the Suffolk-Nansemond Historical Society.)

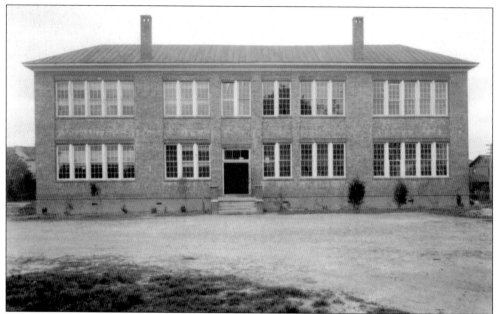

Rev. William W. Gaines, pastor of the First Baptist Church, founded the Nansemond Collegiate Institute in 1890. The school was located on East Washington Street near Fifth Street. It was open to black children, who were not allowed to go to the public schools at that time. The building above was completed in 1928 but a number of fires caused damage and with a lack of funds and competition, the school closed in 1939. (Courtesy of the State Library of Virginia.)

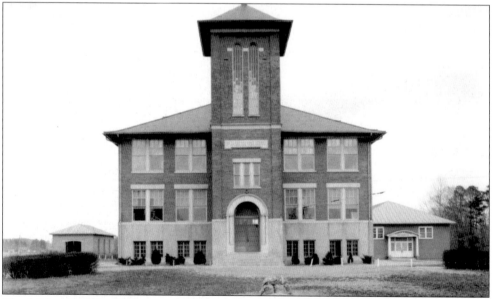

The high school in Driver was unique in that it was the "Second Congressional District Agriculture High School." It was opened in the early 1900s and was coeducational. There were dormitories for students and teachers and the building was later named for the superintendent of instruction there, J.B.L. DeJarnette. The school fell into disrepair and was torn down to make way for a new school. (Courtesy of the State Library of Virginia.)

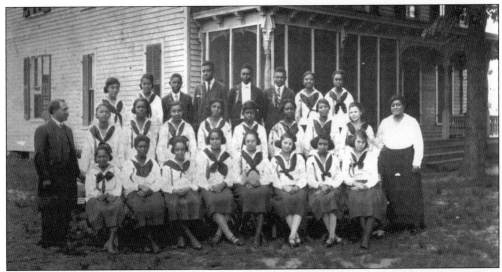

The Nansemond Collegiate Institute was created to educate the young people of the black community. The 1922 graduating class of Nansemond Collegiate Institute, from left to right, are (first row) Mrs. Deliah C. Johnson, Sally Langston, Goldie Morris, Maggie Langston, Elsie Edwards, Porter Raney, JoAnna Conner, Margaret Ricks, Bessie May, and Rev. T.J. Johnson (principal); (second row) Kanora Wiggins, Reba Piece, Alease Roberts, unidentified, Whillott White Lowe, Catherine Malone, and Vessie Pretlow; (third row) Maude Brinkley, ? Green, Walter Richardson, Eddie Clary, Miles Ballard, Lorenza Morris, Pearl Alphin, and Ira Green. (Courtesy of the State Library of Virginia.)

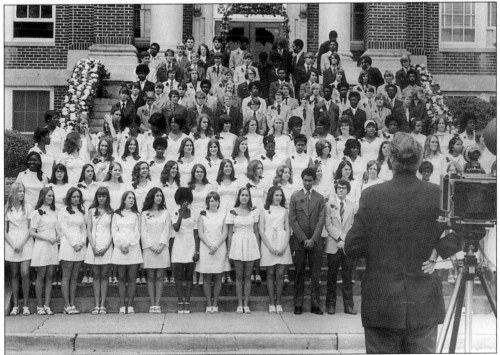

The 1972 graduating class of Suffolk High School posed for the traditional class photo on the steps of the school. (Courtesy of Martha Moore Turner.)

Elgin Lowe was an educator in Suffolk who began his own higher education at the Nansemond Collegiate Institute. He graduated from there and held several positions in the Suffolk Education System. He served as principal of Booker T. Washington Junior High School in the 1970s as well as being director of personnel for Suffolk Public Schools. (Courtesy of the State Library of Virginia.)

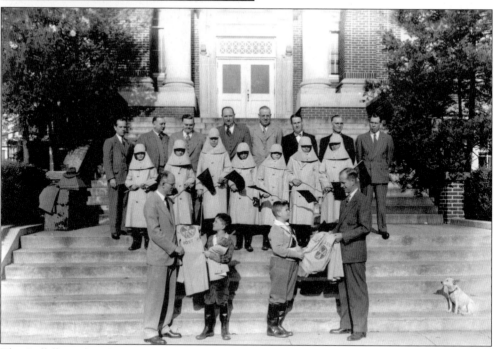

The Suffolk High School PTA distributed raingear to the safety patrol members to prepare for inclement weather. They were displaying their rain jackets and pennants on the steps of the high school. The picture was taken on December 4, 1947. (Courtesy of the Suffolk-Nansemond Historical Society.)

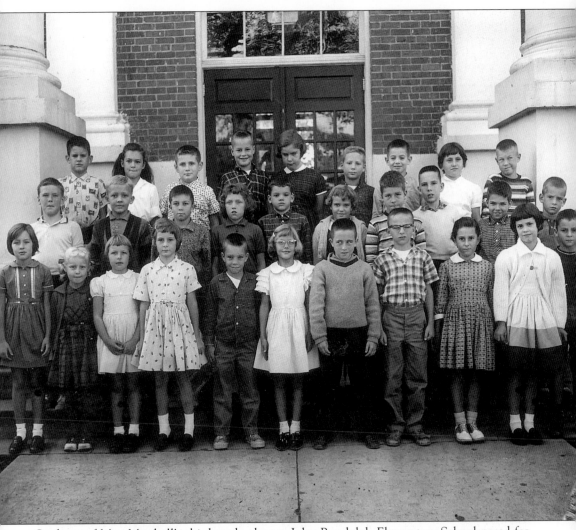

Students of Mrs. Marshall's third grade class at John Randolph Elementary School posed for their class picture on the steps of the school in October 1961. The students, from left to right, are (front row) Frances Watson, Donna Cooley, Nancy Baird, Jane Brinkley, Steve Thompson, Sharon Elliot, Michael Stobb, Lynn Writtenberry, Gail Smith, Millie Dale, and Pete Dudley; (second row) Ben Ellis, Bill Jones, Steve Meagison, Terry Fry, David Britt, Patsy Britt, Johnny Casper, Frankie Salmon, David McCullery, and Kyle Marlin; (third row) Randy Carter, Peggy Hall, Mike Moritz, Wayne Holland, Muff Johnson, Hunter Haslett, Edward Saecker, Shay Davies, and Kent Spain. (Courtesy of the Marion J. Watson Collection.)

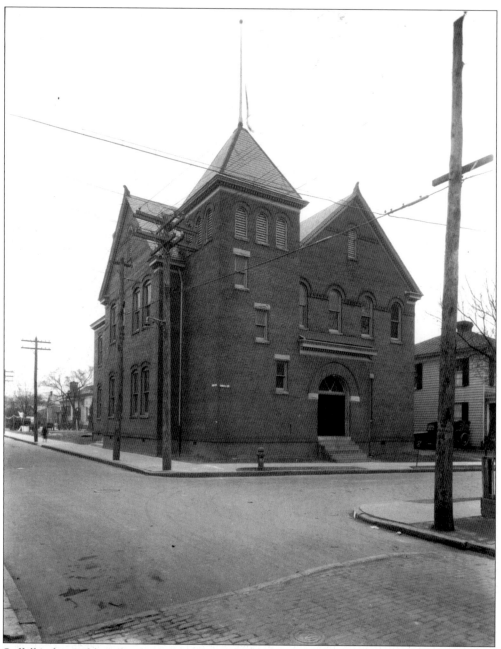

Suffolk's first public school stood on the Southeast corner of the intersection of Saratoga and Market streets. It was built in 1893. When Jefferson school was built in 1912 it became a municipal building. This picture was taken after 1911. the building was eventually torn down. (Courtesy of the Suffolk-Nansemond Historical Society.)

This is a photograph of the graduating class of Thomas Jefferson High School as they appeared in the newspaper in 1916. The graduates only had to complete 11 grades at that time. Many members of the class remained in Suffolk to work and raise families. Some of their descendants continue to make Suffolk their home. The students, from left to right, are (front row) Thomas H. Birdsong Jr., C. Pansy Privott, Frederick W. Norfleet (salutatorian), Evelyn C. Lloyd, and Pepple McG. Burton; (second row) Willie Oursler, Ernest T. Dalton, Virgie A. Ely, G. Richardson Joyner, and Margaret G. Parker; (third row) Lucile S. Moore, Lucy L. Wells (valedictorian), Sidney L. Maxey (class president), Edith E. Saunders (secretary/treasurer), and Irma C. Holland; (fourth row) R. Curtis Saunders, Ruby V. Benton, Willie C. Jones, Bernice M. Lehman, and V. Marshall Andrews; (fifth row) H. Elizabeth Evans, Cornelia C. Parker, Hudson D. Baines, Helen P. Finch, and Georgia M. Gay; (sixth row) Ralph H. Byrd and Gatis R. Yates. (Courtesy of the State Library of Virginia.)

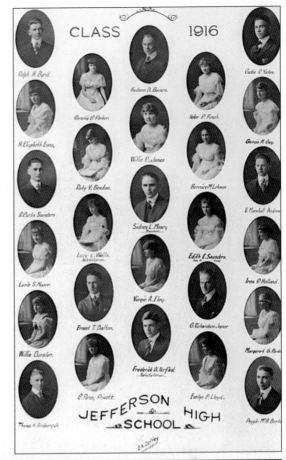

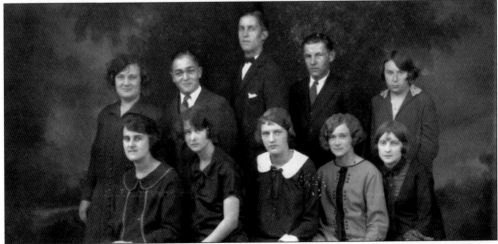

The staff of Chuckatuck High School, in the 1924–1925 school year, was made up of only 10 people to take care of the entire school. They are, from left to right, (front row) Marion Saunders, Alice Lee Underwood, Mary Lee Godwin, Dorothy Moore, and Kathleen Brough; (back row) Eugenia Eley, W.G. Saunders Jr., Teddie Fields, Selby Mardre, and Elaine Shreves. (Courtesy of the Suffolk-Nansemond Historical Society.)

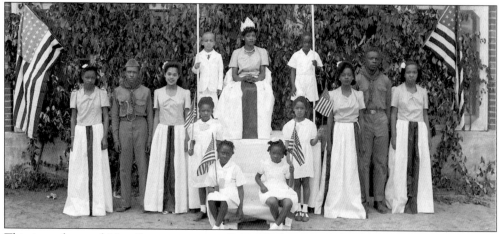

This is a photo of May Day activities at B.T. Washington School on May 1, 1941. These students and boy scouts are participating in a May Day ceremony with the Crowning of the May Queen and her attendants. The patriotic flags are a demonstration for the war effort. (Courtesy of the State Library of Virginia.)

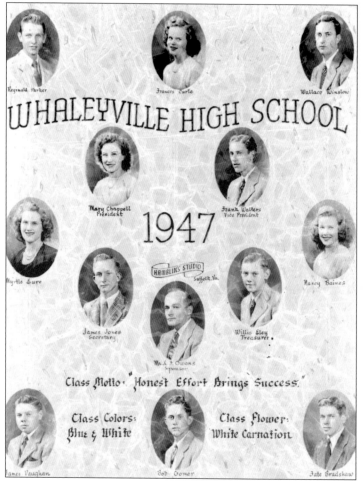

Whallyville High School was originally built in 1915. It would serve the students of the area until the end of the 1989–1990 school year. The class of 1947 was made up of 12 students. Their class motto was "Honest Effort Brings Success" and their class colors were blue and white. The students, from left to right, are (front row) James Vaugh, Bob Gomer, and Tate Bradshaw; (second row) Myrtle Eure, James Jones, Secretary, Mr. L.F. Owens (sponsor), Willis Eley (treasurer), and Nancy Baines; (third row) Mary Chappell (president) and Frank Walters (vice-president); (fourth row) Reginald Parker, Frances Curle, and Wallace Winslow. (Courtesy of the State Library of Virginia.)

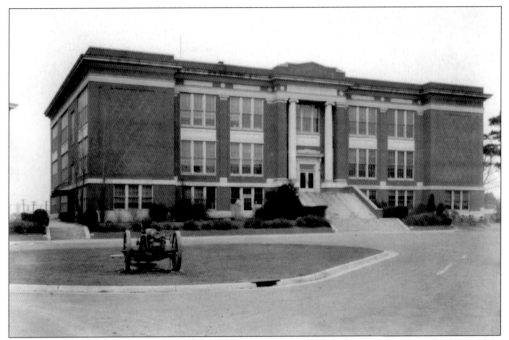

Suffolk High School was built in the late 1920s and served the community until it closed in 1990. It started as the white high school in Suffolk but accommodated all high school students in the city after integration. The high school had many championship teams in sports and the band and theater productions were very successful over the years. The school was closed in 1990 but may soon be reopened as a cultural center to serve the residents of Suffolk. (Courtesy of the Suffolk-Nansemond Historical Society.)

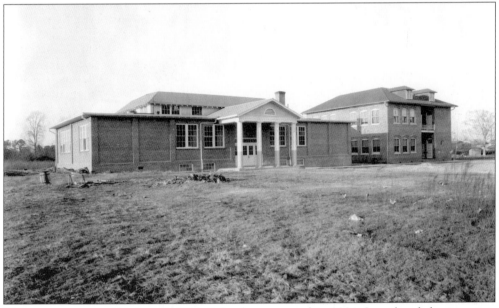

The new one-story Chuckatuck High School was erected in 1924. It replaced the two-story school to the right. Both buildings were closed and sold to Saunders Supply when John Yeates High School opened. (Courtesy of the State Library of Virginia.)

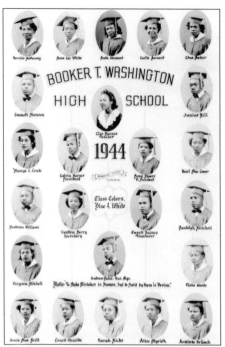

B.T. Washington High School was built to serve as the black high school for many years before the integration of the city schools. It was the junior high school for some time and now has kindergarten through fifth grades. Twenty-three students represented the class of 1944. From left to right, they are (first row) Jessie Mae Britt, Ersell Shields, Sarah Ricks, Alice Myrick, and Arminta DeLoach; (second row) Virginia Mitchell, Andrew Bates (business manager) and Viola Goode; (third row) Henderson Williams, Cynthia Berry (secretary), Everett Rainey (treasurer), and Randolph Mitchell; (fourth row) Mamye L. Crute, Calvin Harper (president), Rosa More (vice-president), and Hazel Mae Cooper; (fifth row) Emmett Manson, Cleo Barnes (teacher), and Junius Hill; (sixth row) Bernice Hawthaway, Rosa Lee White, Ruth Stewart, Cecile Bernard, and Edna Baker. (Courtesy of the State Library of Virginia.)

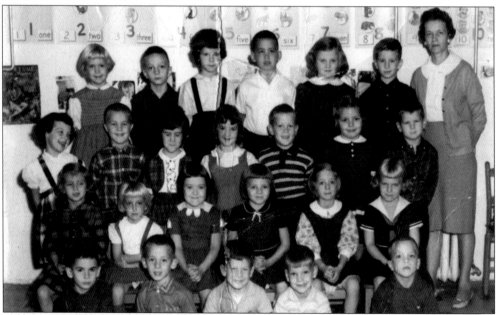

There was a time in Virginia when school systems did not offer public kindergarten. A local woman, Mrs. Stephenson, had a kindergarten located in the Lakeside neighborhood. The photograph was taken on November 8, 1963. From left to right, the students are (first row) John Stoval, unidentified, Ross Jaffee, Jay Faircloth, and Bart Zekert; (second row) Theresa ?, Pam Harrell, Margaret Crowgey, Robin Privott, unidentified, and Patricia Howell; (third row) Paulette?, unidentified, Nancy Parr, Denise Davis, Bart Webb, Kerry Gwosh, and Billy Darden; (fourth row) Elizabeth Joyner, Charles Hassell, Jean Mauck, Tosh Cahoon, Cathy Winslow, Shelton Carter, and Mrs. Stephenson. (Courtesy of Elizabeth Joyner Taylor.)

Five

ORGANIZATIONS

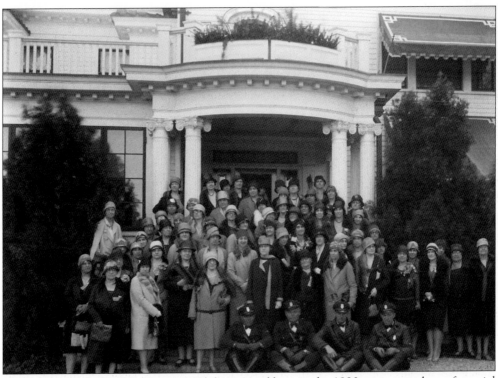

The women of the Suffolk Woman's Club, pictured here in the 1930s, were members of a social club that also did community service. The members pictured here at the Obici House near Driver, Virginia, sponsored parties and welcomes for the service men from Suffolk as well as those visiting from other parts of the country. They had a building on Bank Street where they held their meetings. (Courtesy of the State Library of Virginia.)

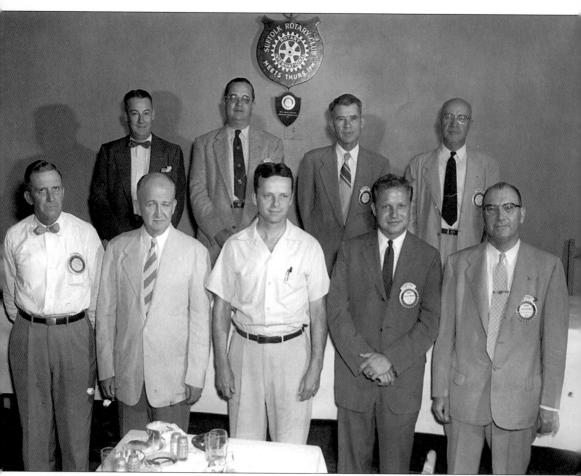

The Rotary Club was organized in Suffolk in 1922. This photo was taken during a regular meeting. The members, from left to right, are (front row) Hall F. Birdsong, J.P. Cross, Irving Coulbourn, Forest Wommack, and Louis DeMoll; (back row) G.I. Wells, Bill Griffin, Quinby Hines, and Harry Pettit. (Courtesy of Elizabeth B. Joyner.)

Floyd Benton was a Suffolk Shriner when Hamlin Studios took this picture in August 1959. He worked for Standard Oil Company for 40 years. He was married to Grayce Benton and they lived on Bosley Avenue. (Courtesy of the State Library of Virginia.)

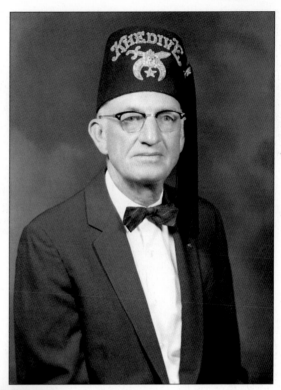

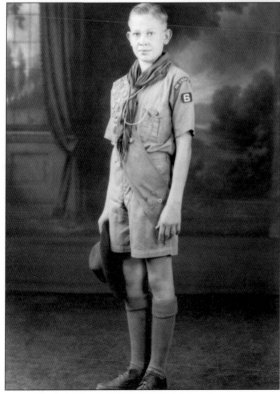

In 1941, Harvey Rawles was photographed wearing his Boy Scout uniform. Harvey was the son of Dr. and Mrs. J.E. Rawles Sr. (Courtesy of the Suffolk-Nansemond Historical Society.)

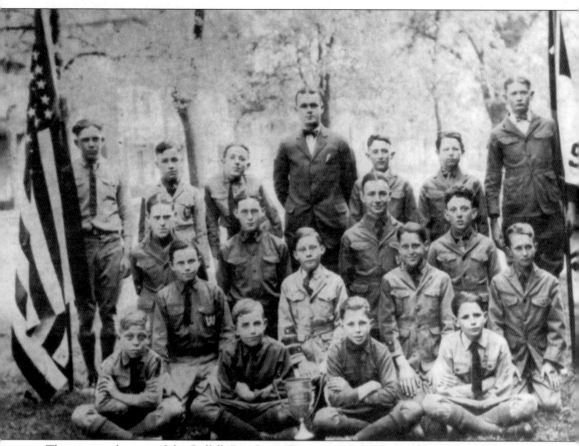

The picture above is of the Suffolk Boy Scout Troop, *c.* 1930. I.P. Brinkley, Claude Eley, Fred Hart, Frank Butler, and Pretlow Brinkley are among those pictured. Fred Hart was the first scout in Suffolk to reach Eagle Scout status. (Courtesy of the Suffolk-Nansemond Historical Society.)

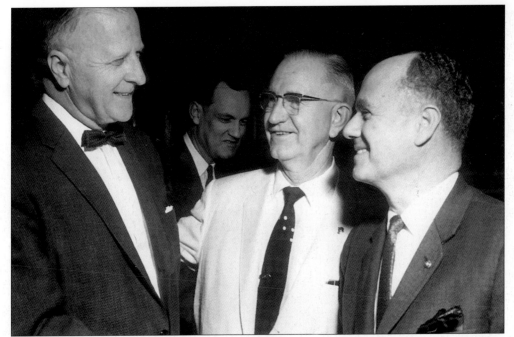

The 15th anniversary celebration of the Suffolk Kiwanis Club was held in 1962 at Planters Clubhouse. The dinner was commemorated by the attendance of the first president of the , George Richardson Joyner Sr. (left); the current president, T.J. LoCascio (right); and the president of the Portsmouth Chapter, Paul Stokley (center). Stokley attended because the Portsmouth Chapter sponsored the Suffolk group when the club was established in 1947. Mills E. Godwin Jr., speaker for the event, is in the background. (Courtesy of the Marion J. Watson Collection.)

On December 2, 1951, the Suffolk Kiwanis Club purchased a "Living Christmas Tree" from Greenbrier Farms to place on the north lawn of the Main Street Methodist Church for the community. The Kiwanis decorated the 20-foot evergreen tree with Christmas lights. The group of Kiwanis members watching the planting on the right side of the tree are, from left to right, Frank E. Howell (Kiwanis Club president), Webb Pinner, W.B. Harrell Jr., and H. Burdge Caton. (Courtesy of the Suffolk-Nansemond Historical Society.)

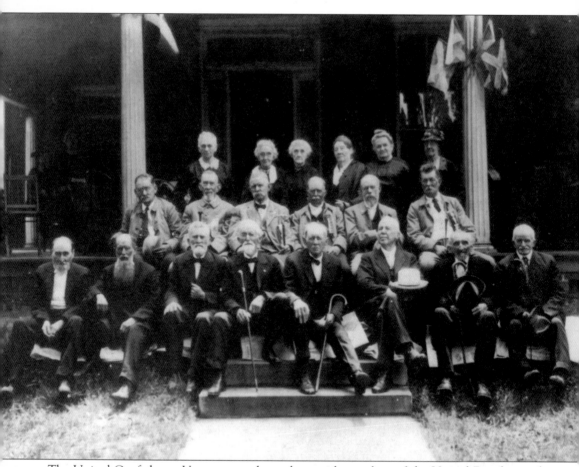

The United Confederate Veterans are shown here with members of the United Daughters of the Confederacy (UDC) Suffolk Chapter #173. The UDC was established in 1897 "to aid the Confederate Veterans, their widows, and oversee cemeteries." The earliest chapter began in 1890. It was disbanded for a time from 1966 until 1997 and then re-activated. The members of both organizations pictured here, from left to right, are (front row) Noah Williams, James Harrison, Butler ?, two unidentified members, William J. Owen, two unidentified members, Phillip Brinkley, and unidentified; (second row) two unidentified members, John F. Hudgins, unidentified, Hugh B. Kelley, and unidentified; (third row) unidentified, Missouri Riddick Withers, Anna Mary Riddick (president of the UDC), Mary Copeland Riddick, and unidentified. (Courtesy of Riddick's Folly, Inc.)

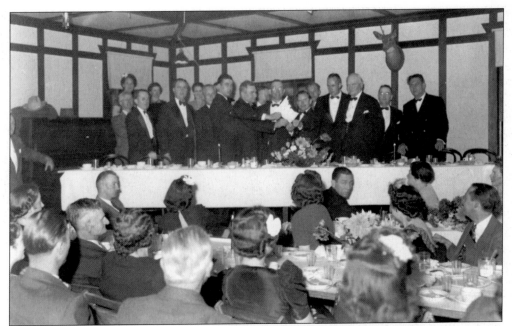

On October 26, 1944 the Elks Club had a party at Planters Clubhouse and held a ceremony in which they burned the mortgage to their building signifying that they had paid off the loan. (Courtesy of the Suffolk-Nansemond Historical Society.)

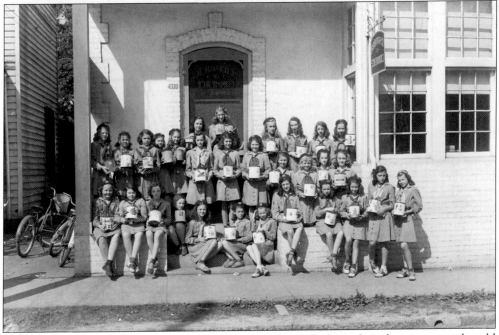

On May 24, 1946, a local Girl Scout troop is photographed standing downtown at the old Chamber of Commerce building at 116 North Saratoga Street. The members of the troop were displaying their tins of Girl Scout cookies they are going to sell. Girl Scouts had only started selling cookies ten years earlier. By 1946 over one million members had joined the national Girl Scout ranks. (Courtesy of the State Library of Virginia.)

The Junior Volunteer Service Corps sponsored a spring fashion show in 1949 to raise money for their work. The group did volunteer work in the community as well as charitable deeds. Five of the participants and members are pictured here, from left to right, (front row) Mrs. J.C. West, Mrs. Robert B. Tynes, and Mrs. C.H. Murden; (back row) Mrs. Katherine Crocker and Mrs. Anderson Maxey. (Courtesy of Elizabeth B. Joyner.)

The Elks Club was established nationally in 1868 and there were several clubs established in Suffolk—this is one of them. (Courtesy of the State Library of Virginia.)

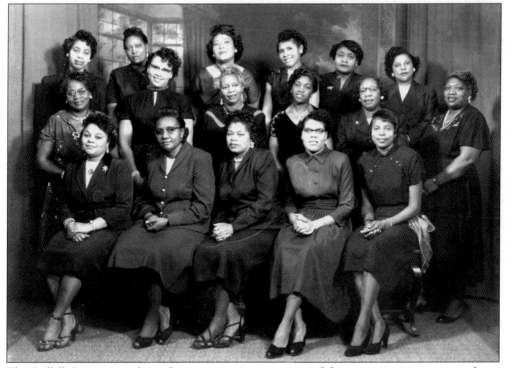

The Suffolk Beauticians formed an organization to meet and discuss topics important to them. They posed for this picture on February 23, 1955. (Courtesy of the State Library of Virginia.)

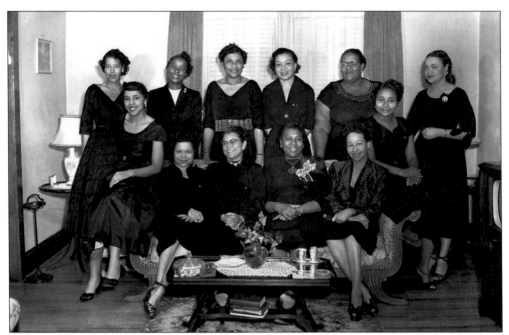

The Alpha Kappa Alpha Sorority, like other sororities and social clubs, had meetings and did community work as well as finding time to have fun. They had their picture taken Valentine's Day, 1954. (Courtesy of the State Library of Virginia.)

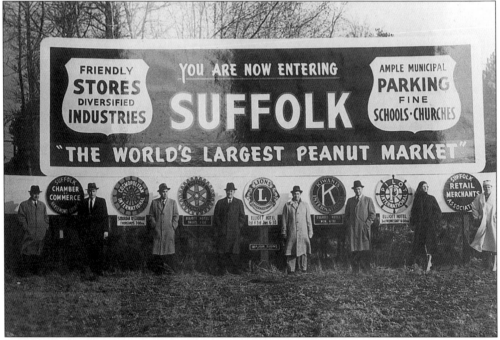

Suffolk has been home to many clubs and organizations over the years. For many years this billboard greeted visitors as they drove into Suffolk. Some of the representatives of the groups advertised are Forrest Wommack, John N. Byrne, Bill Missett, and Jimmy Jones. (Courtesy of the Suffolk-Nansemond Historical Society.)

Six
THE PEANUT INDUSTRY

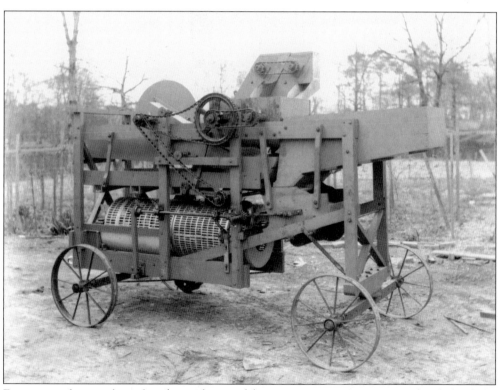

Farmers used a number of tools to plant and harvest peanuts. A company that helped the farmers was the Benthall Machine Co. J.T. Benthall and Finton Ferguson invented a machine to make it easier for farmers to harvest the peanuts. Mules powered the first machines. Later machines would be powered by gas. (Courtesy of the State Library of Virginia.)

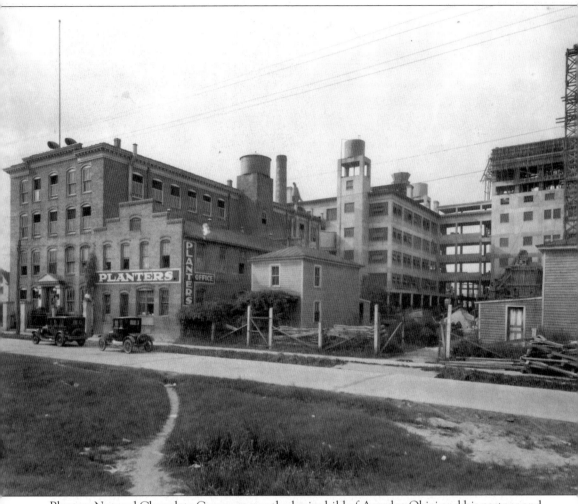

Planters Nut and Chocolate Company was the brainchild of Amedeo Obici and his partner and brother-in-law Mario Peruzzi. They began working in the peanut business in 1896 and settled in Suffolk in 1913. The company flourished with marketing intelligence from Obici himself. Other plants and offices were opened in San Francisco, New York, Chicago, Boston, and Philadelphia. The company was purchased by Standard Brands in 1961, and 20 years later became part of Nabisco/Standard Brand. (Courtesy of the State Library of Virginia.)

Amedeo Obici was born in Italy in 1877 but came to America 11 years later. He did a variety of jobs before he settled on becoming a street vendor selling peanuts in Wilkes-Barre, Pennsylvania. He went into partnership with his brother-in-law, Mario Peruzzi, and the business grew. Obici had perfected his own method of preparing peanuts and started marketing peanuts roasted and with chocolate. He named his business Planters in 1906. In order to expand his business, he moved to Suffolk in 1913 and opened a processing plant. He advertised in magazines and opened stores. A 14-year-old student in Suffolk designed the "Mr. Peanut" logo. He was well known for his philanthropic deeds. He took care of his employees during lean years and left money to fund hospitals and other charitable causes. He was married to Louise Obici to whom he dedicated the funds for a hospital in Suffolk. He and Mrs. Obici are buried behind their portraits in the Louise Memorial Hospital. (Courtesy of the State Library of Virginia.)

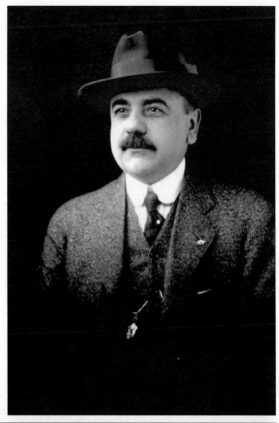

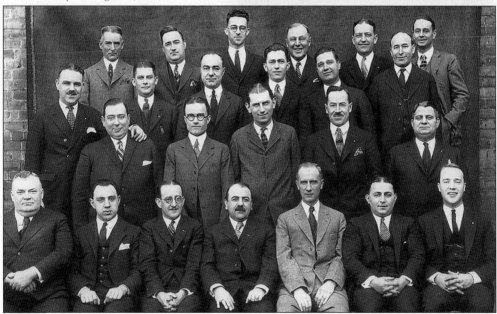

Amedeo Obici is pictured here in the center of the front row with some of his workers from the Planters Nut and Chocolate Company in 1917. (Courtesy of the Suffolk-Nansemond Historical Society.)

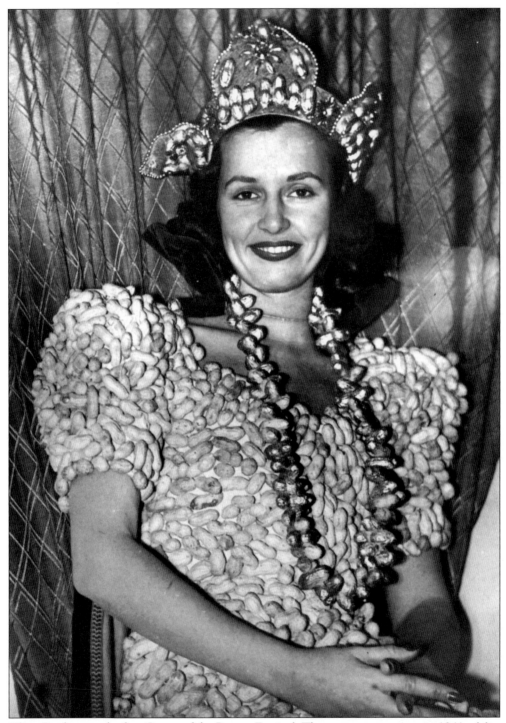

Olive Cawley was the first Queen of the Peanut Festival. There were two queens in 1941—Miss Cawley in January and Miss Pat Donnelly in October. There were parades and celebrations at both the January event and the National Peanut Exposition event in October. Miss Cawley is wearing a peanut dress made especially for the event. (Courtesy of Riddick's Folly, Inc.)

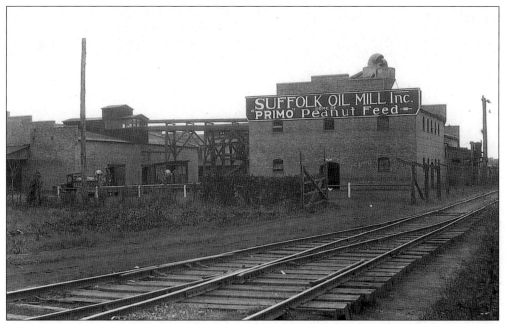

L. Wellons Caulk Jr. owned the Suffolk Oil Mill Inc. for many years. He was married to Louise Caulk and they lived in Riverview. J. Lewis Rawls later owned the mill. The plant was used to turn ground peanut meal from the local plants into oil to be sold and shipped out. They were advertised as "The Manufacturers of 'Somillo' Brand Peanut Oil." (Courtesy of the Suffolk-Nansemond Historical Society.)

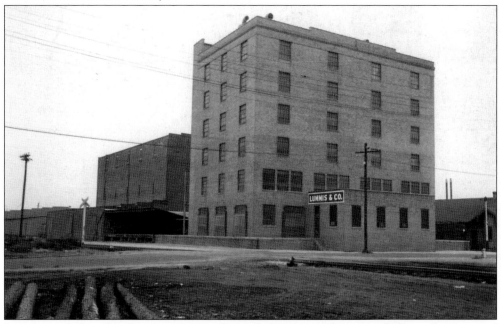

Lummis and Co. played a prominent role in the peanut industry as shellers, cleaners, and processors of peanuts and peanut products. The company was originally founded in Philadelphia, Pennsylvania in 1879 and opened facilities in 1901 in Suffolk. Henry L. Lummis was the owner. (Courtesy of the Suffolk-Nansemond Historical Society.)

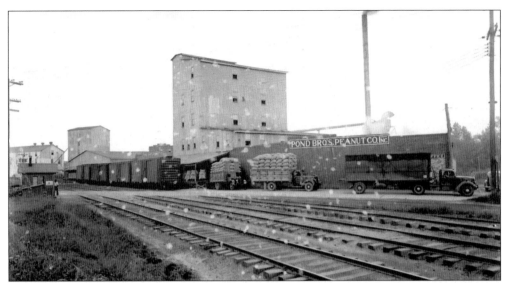

Pond Brothers Peanut Co., Inc. was created from the purchase of the Pope Peanut Co. in Suffolk in 1915. Fire destroyed their facilities in 1920 and they rebuilt in 1921. C.B. Pond, Sr., W.T. Pond Sr., and L.L. Pond founded the company. C.B. Pond, who served as president, had worked in the Pope Peanut Company as well as the Suffolk Peanut Company before he and his brothers started the firm. W.T. Pond began his career in the lumber business before joining the firm and L.L. Pond worked for Pope Peanut Co. until the establishment of Pond Brothers Peanut Co. The Pond family continued to run the company for several generations. Their peanuts were marketed around the country. (Courtesy of the State Library of Virginia.)

Preparing peanuts is an art that many women in Suffolk have perfected over the years. Mrs. Hall F. Birdsong teaches her granddaughter, Nancy Joyner, how to blanch the peanuts. Nancy is the daughter of G.R. Joyner Jr. and his wife, Elizabeth Birdsong Joyner. The photo was taken to put in the local paper, the *Suffolk News Herald*, to commemorate National Peanut Week. Mrs. Birdsong included recipes in the article demonstrating how to fix the peanuts as well as how to make a peanut brittle. This article, published in the early 1960s, also discussed how you could use peanuts "to serve at wedding receptions, cocktail parties, teas, when you are playing bridge, or even with a dessert course at an afternoon party." (Courtesy of Elizabeth B. Joyner.)

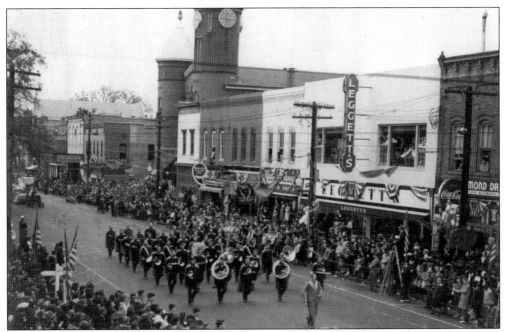

The parade for the October 31, 1941 Peanut Exposition brought out a banner crowd. Thousands of people were in attendance when the parade began. Floats representing peanut companies as well as organizations were included in the parade with bands and dignitaries. The event was considered a spectacular success. (Courtesy of the Suffolk-Nansemond Historical Society.)

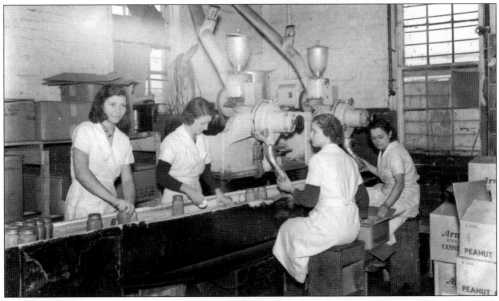

Many of the functions in producing Peanut Butter were done by hand. Here, on June 12, 1940, these factory women are putting the peanut butter in a jar using a machine and then putting seals on the jars. Automation would eventually come to the plants and reduce number of employees necessary to produce the peanut products. (Courtesy of the Suffolk-Nansemond Historical Society.)

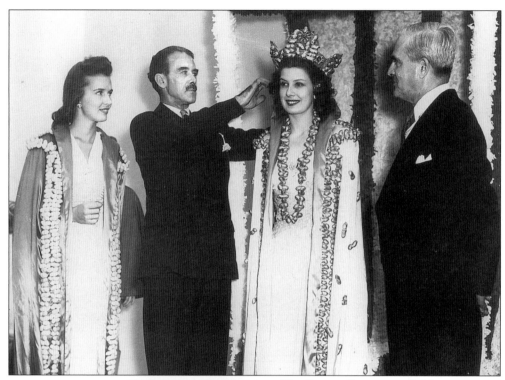

The Peanut Exposition Celebration in October of 1941 brought dignitaries to Suffolk. Picture here, during the crowning ceremonies are, from left to right, Olive Cawley of New York, the first Queen, The Honorable Richard G. Casey, Australian Minister to the United States, Queen Patricia Donnelly of Detroit, the 1939 Miss America, and governor James H. Price. (Courtesy of the Suffolk-Nansemond Historical Society.)

George Nichols, an employee of Pond Brothers Peanut Company, takes a cigarette break before going back to work. He and other workers in the community made their living at the peanut companies in the area. (Courtesy of the Suffolk-Nansemond Historical Society.)

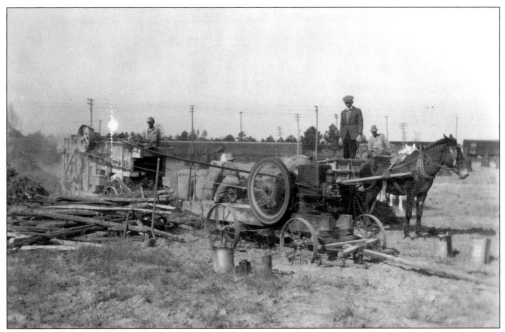

Farmers are working with their hired hands to harvest the peanut fields with the latest technology they had during that time. Horses and mules served many purposes on the farm and were vital to the harvesting of peanuts until gas engine machines were readily available. (Courtesy of the Suffolk-Nansemond Historical Society.)

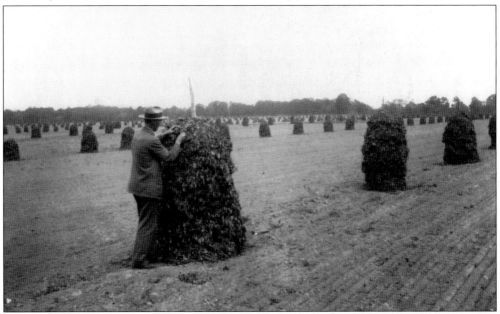

Peanuts were traditionally gathered by hand or using mules or horses to pull out the vines. The vines and peanuts were then stacked on poles to dry. This could take several days or even weeks. The man in the picture above is inspecting the crop to see if it is ready to be picked. This was the standard process well into the 1940s. With the invention of machinery, the process and volume of cultivation increased. (Courtesy of the Suffolk-Nansemond Historical Society.)

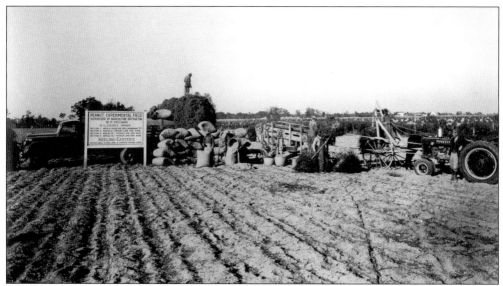

Workers are in the field with horses and tractors, harvesting in an experimental peanut field. The owner of the field was R.C. Council and the instructor supervising the experiment was W.H. McCann. The test was using an oyster shell, flour lime, and muriate potash by Keeling-Easter. The sign defines the different sections of the field and what was used. Farmers were very interested in test results that could show better crop yield and improved harvests. (Courtesy of the Suffolk-Nansemond Historical Society.)

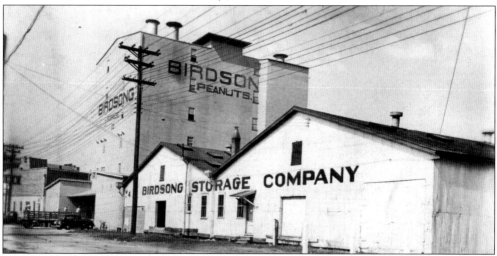

Birdsong Corporation was established in 1911 when Thomas H. Birdsong moved his family to Suffolk and started Birdsong Storage Company. He began the business in a brick building he leased on Hall Avenue. The firm's main function was to store peanuts and sell them on commission. He began milling peanuts in the 1930s and then he started shelling. During the Depression, times were hard but the company diversified and when Thomas H. Birdsong Sr.'s son joined the firm, the business started to flourish again. Birdsong Enterprises was built by the hard work of numerous family members and today the company is still run by a large number of Birdsongs. Over the years, the company was able to move into a number of other interests related to the harvesting, producing, and transporting of peanuts and continues to this day. (Courtesy of the Suffolk-Nansemond Historical Society.)

Seven

ENTERTAINMENT,
SPORTS, AND SOCIAL
EVENTS

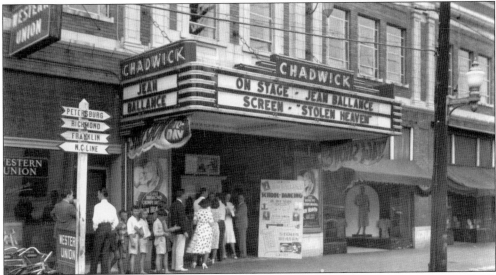

Children and teens could be entertained on a Saturday afternoon going to the Chadwick Theater to see a variety of serials each week of cowboys and Indians, detectives, and spacemen. Here moviegoers are lined up in the summer of 1938 to buy tickets to see the Jean Balance School of Dance with Doris Smith performing, and the movie *Stolen Heaven* starring Gene Raymond and Olympe Bradna. Gene Raymond was the husband of the singer and actress Jeanette MacDonald. (Courtesy of the Suffolk-Nansemond Historical Society.)

A women's political gathering was held at the home of Mrs. F. Whitney Godwin at 504 West Washington Street on July 3, 1961 in honor of the wives of candidates for the highest Virginia state offices. Pictured here, from left to right, are Mrs. R. Curtis Saunders Jr. (daughter of the host), Mrs. Albertis Harrison(whose husband was running for governor), Mrs. Mills E. Godwin Jr. (whose husband was running for lieutenant governor), and Mrs. Robert V. Button (whose husband was running for attorney general). (Courtesy of Riddick's Folly, Inc.)

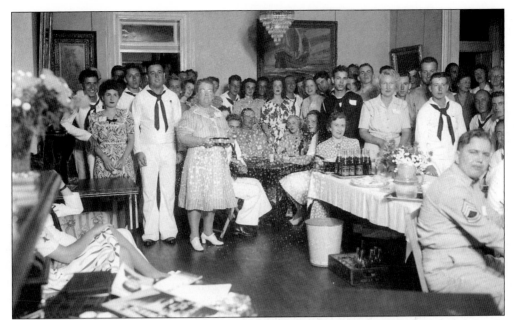

On March 21, 1943, The Women's Club entertained soldiers at Bank Street. Anna Goode Turner is standing behind her mother at the center of the picture. In the background is Hilda Harrell. The club offered many services to help support the war effort. (Courtesy of the Suffolk-Nansemond Historical Society.)

A kickoff breakfast was held the morning of October 22, 1951 for the 1951 Community Chest Drive. Division leaders and captains gathered after breakfast to receive assignments for the drive. J. Melvin Lovelace, campaign chairman, distributed the kits for donation collection. Those shown in the picture above are, from left to right, Jack W. Nurney, T.J. LoCasio, Melvin Lovelace, L. A. Familant, Elmer C. Ehler, and Jimmy Melito. (Courtesy of the Suffolk-Nansemond Historical Society.)

An adventure awaited four Suffolk High School juniors the summer of 1948 when they decided to take a bike trip to Florida. They worked to purchase 28-inch Coventry Eagle 3-speed bicycles imported for them from England by Montague Mountcastle, owner of a sporting goods store in Suffolk. The four boys, shown above with one of their bikes, from left to right, are Dr. James Parker Cross Jr., Charles Taylor Hosier, G.R. Joyner Jr., and Richard Lee Sykes. They traveled for 24 days from Suffolk to Florida and almost made it back before having to ride the bus home. The four remained lifelong friends. (Courtesy of G.R. Joyner Jr.)

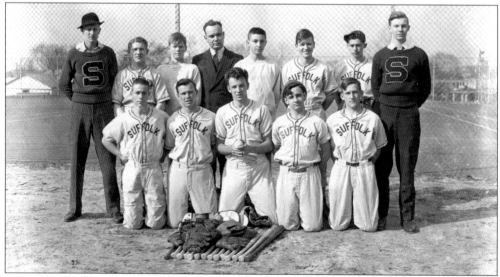

The 1942 Suffolk High School Baseball Team is pictured here on the field. The two captains in their letter sweaters flank the team. In the center is the coach, Lewis "Captain Dick" White. Capt. White was a teacher and coach for Suffolk High School for many years. (Courtesy of the State Library of Virginia.)

In 1927 there were a group of Suffolk High School students who formed a band called the Night Hawk Orchestra. They are seen here performing in front of the school. The members, from left to right, are (first row) Irving Ward, Richard Pond Sr., and William Eley Jr.; (back row) W.T. Pond, Bruce Elliott, ? , Garnet Smithers, Johnnie Morgan, and Ham Harrell. (Courtesy of the Suffolk-Nansemond Historical Society.)

The Suffolk High School Drama classes performed a play in the auditorium. Performing arts was a strong part of the school program. The sheet music on the piano is Fanny Brice's "Be Yourself!" The period is c. 1930. (Courtesy of the State Library of Virginia.)

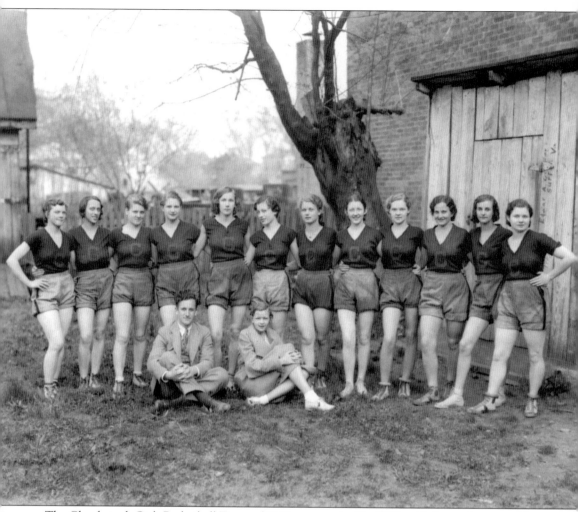

The Chuckatuck Girls Basketball Team of 1932 was coached by Wilbur Bailey and managed by Matsie Moore. The team members, from left to right, are (front row) Wilbur Bailey and Matsie Moore; (back row) Capitola Rountree, Louise Jakeman, Sally Moore, Dottie Chapman, Irene Pinner, Jessie Willoughby, Leah Godwin, Edna Horton, Elizabeth Norfleet, Margaret Rhodes, Inez Hackney, and Elizabeth Piece. (Courtesy of the Suffolk-Nansemond Historical Society.)

The Laurel Cliff Country Club, located off of Riverview Drive, was a members only club established in 1916. It was created by a group of residents that were headed by James Corbitt. The clubhouse was built in 1920 and the grounds included a golf course and tennis courts. The club only lasted for about ten years. The clubhouse was abandoned until R.A. Harry turned the grounds into a golf course. The building was finally torn down after the 1950s due to neglect. (Courtesy of the Suffolk-Nansemond Historical Society.)

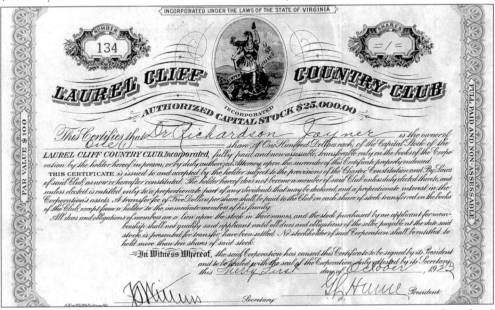

A stock certificate from the Laurel Cliff Country Club was issued to Dr. G.R. Joyner Sr., a local physician in Suffolk. A stock certificate was given out with membership in the Country Club. This certificate was issued in 1922. (Courtesy of the Marion J. Watson Collection.)

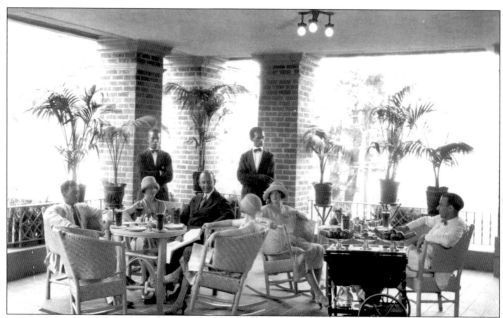

The Palm Court at the Elliott Hotel on Main Street was frequented by many residents and served as a social gathering place to eat, attend receptions, and attend meetings. The patrons here enjoy lunch on a summer day. Seated at the left table are Erskin Watkins (in the light suit) and Virginia Bennett. At the right table are Judith Brewer Godwin and P.M. "Pep" Burton. (Courtesy of the Suffolk-Nansemond Historical Society.)

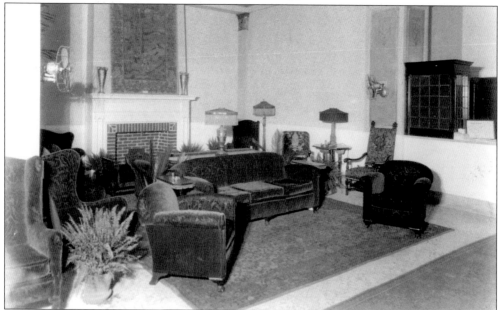

The Elliott Hotel, built in 1925, was a gathering place for visitors as well as residents of Suffolk. In later years, it was named the Hotel Suffolk. The hotel served the needs of the traveling community as well as housing some local businesses. Virginia Power had an office in the building. Wedding receptions and dances were just some of the events that were held there. This is a picture of the lobby in 1925. (Courtesy of the Suffolk-Nansemond Historical Society.)

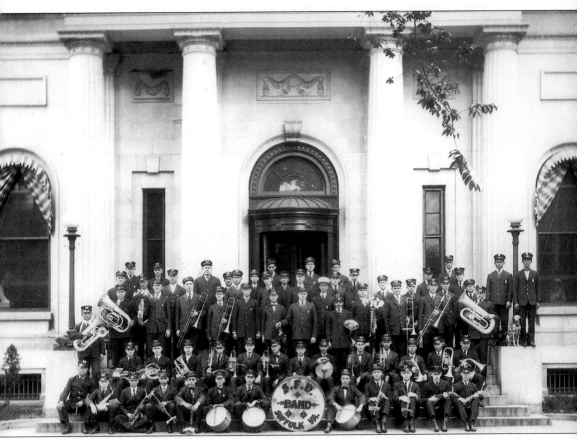

Suffolk Fire Department Band assembled in front of the new post office on Main Street in the 1920s. The band, as did their predecessors, performed at concerts in the park, theaters, and parades. (Courtesy of the Suffolk-Nansemond Historical Society.)

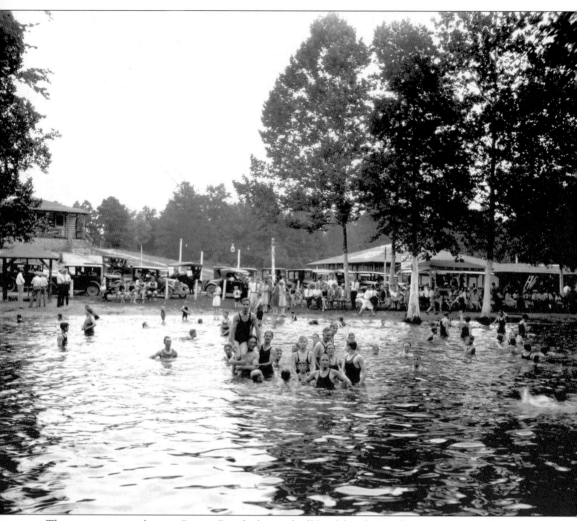

This picture was taken at Conan Beach, located off Pitchkettle Road, in June 1928. This was a popular place for residents to get away from the summer heat and have fun with their families. The Parkers ran the area and it was active from the 1920s until about 20 years later. The pavilions in the background sold items like candies and sodas and there were dances there from time to time. (Courtesy of the State Library of Virginia.)

June of 1951 was not a good month for E.E. Wagner. A Portsmouth cement truck hit his house at 342 North Main Street on June 14. He looks in disbelief at the scene of the accident. That month in Suffolk, three other accidents involving cars and houses happened. (Courtesy of the Suffolk-Nansemond Historical Society.)

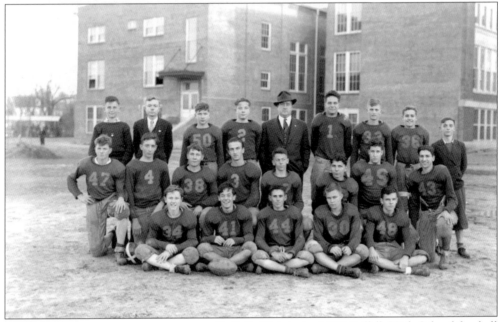

Football was a very competitive sport in Suffolk. This is the 1920 Suffolk High School football team with their coaches behind Suffolk High School. The turnout for the games included alumni, students, and patrons in the community. (Courtesy of the State Library of Virginia.)

Katherine Crocker is dressed in the Red Cross Uniform she wore as executive director of the local American Red Cross chapter in Suffolk. She held that position throughout World War II. She was married to Henry Crocker. (Courtesy of Elizabeth B. Joyner.)

The Red Cross, pictured here in 1941, would assist with any needs that were required. They would transport people and teach classes on a variety of subjects including childbirth, hygiene, and many other health-related topics. Here, two Red Cross workers are assisting a new mother and her infant child. (Courtesy of the Suffolk-Nansemond Historical Society.)

The Dismal Swamp, a large part of which is in the boundaries of Suffolk, has served as entertainment for residents and visitors for a along time. It was used to carry barges of lumber and other products. The Dismal Swamp also became a haven for fugitives who sought refuge from the law. The federal government rescued the canal, built in the late 1700s, in 1829 when it fell into disrepair. However, it never regained its importance due to the development of modern modes of transportation. It is now a national wildlife refuge and is overseen by the Department of the Interior. (Courtesy of the Suffolk-Nansemond Historical Society.)

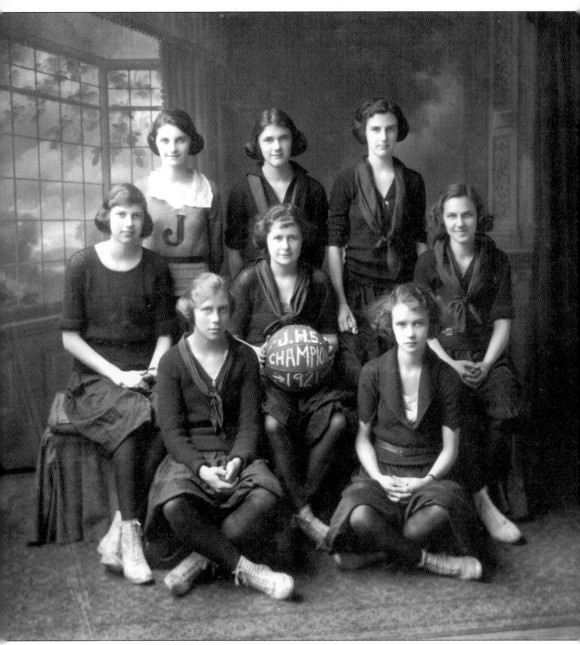

In 1921, Jefferson High School girls' basketball team was made up of nine girls of various ages. The members, from left to right, are (front row) Frances Birdsong Darden and Lydia Wyatt; (second row) Liza Causey Flintoff, Virginia Taylor, and Lucy Manning Wells; (last row) Mabel Jackson Turner, Elizabeth West Birdsong, and Margaret Causey Godwin. The coach, not pictured, was Sue Bryant of Newsoms, Virginia, who later married Thomas Woodward. (Courtesy of the Suffolk-Nansemond Historical Society.)

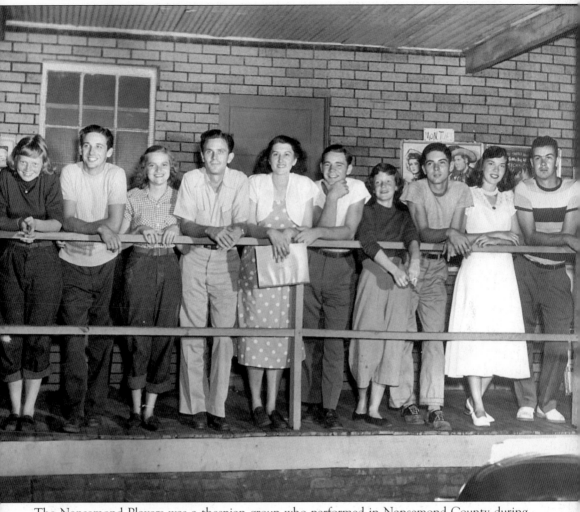

The Nansemond Players was a thespian group who performed in Nansemond County during the summer of 1949. They were created from a group of young people who had been performing half-hour plays for radio audiences at the local radio station, WLPM. The group also did free weekly performances at the Whaleyville Theater. The members of the troupe not only performed in the plays but also did all of the other jobs necessary to put on a performance. Troupe members, from left to right, are Cleo Holladay (stage manager), Richard Sykes (art director), Eleanor Williams (decoration hand), Bill Kitchin (business manager), Frances Joyner (director and founder), Allan Wiliford (construction manager), Catherine Holladay (decoration hand), Sammy Austin (assistant stage manager), Bette Lou Penn (painter), and George Mizelle (electrician). Not pictured are Ida Cohoon (makeup director), Andy Maxey (sound effects director), Dick Joyner (set construction), and Helen Buffkin (wardrobe director). (Courtesy of the Marion J. Watson Collection.)

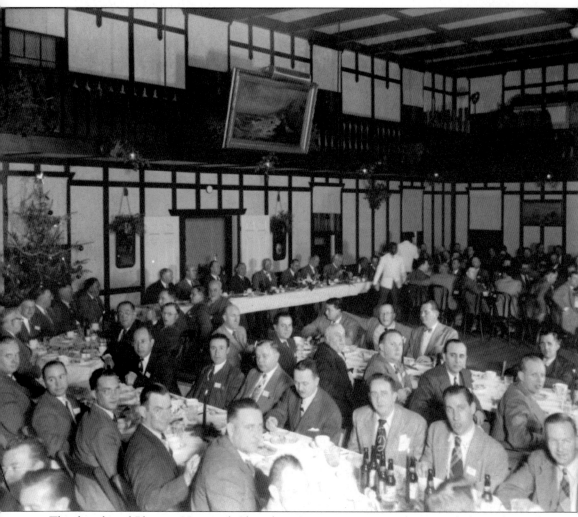

The founder of Planters Nuts and Chocolate Company was very concerned about the well being of his employees. Obici built the Planters Clubhouse so they would have a place to go, relax, hold meetings, and attend various functions. This picture, taken in the big hall at Planters, shows a group of men attending a function on December 30, 1948. (Courtesy of the State Library of Virginia.)

In this photograph, Mary Baldwin alumni meet for a celebration. They are, from left to right, Mrs. Fenton Priest, Mrs. R. Curtis Saunders Jr., and Mrs. John A. Mapp. (Courtesy of the Suffolk-Nansemond Historical Society.)

In 1969, Suffolk High School held their 23rd Annual Peanut Bowl. The parade included floats made by the different classes of the high school. That year Virginia "Jinks" Lemmon was the homecoming queen. The Suffolk Red Raiders football team played the Gloucester High School Dukes. They beat Gloucester and became the district champions. Rick Joyner is one of the football players on the prize-winning float. (Courtesy of the Marion J. Watson Collection.)

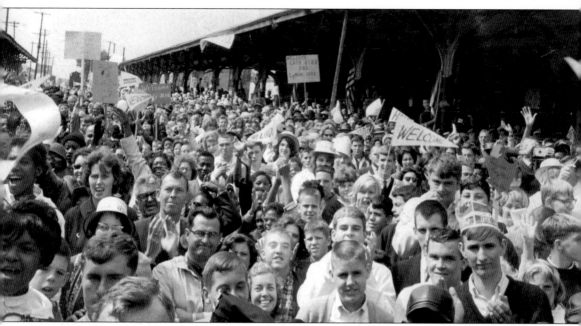

In 1964, Lady Bird Johnson, wife of President Lyndon Baines Johnson, campaigned for her husband by taking a whistle stop tour of eight southern states. The train, dubbed "The Lady Bird Special," stopped in Suffolk at the Norfolk and Western Railroad. Many of the townspeople and students came out to greet her. (Courtesy of the Suffolk-Nansemond Historical Society.)

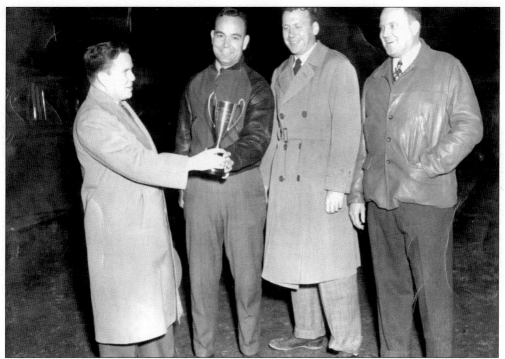

Awards were given out for a football success by the Suffolk High School football coaches in the 1940s. The coaches, from left to right, are Roy Richardson, Lewis "Captain Dick" White, Art Jones, and Dick Hunbert. White taught and coached at Suffolk High School well into the 1960s and Art Jones later became the principal of Suffolk High School in the 1960s and 1970s. (Courtesy of the Suffolk-Nansemond Historical Society.)

This speedboat, the *P-Nut*, competed in races in the 1940s and was piloted by Speedo Thompson, a local businessman. (Courtesy of the Suffolk-Nansemond Historical Society.)

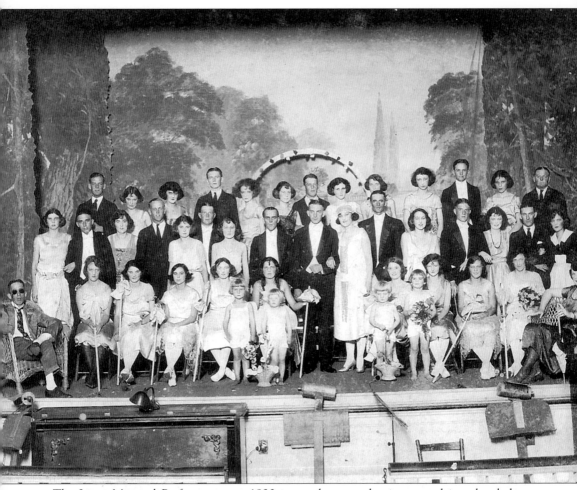

The Lions Minstrel Performance, c. 1920, was a large production staged in a local theater. Among those pictured here are Ida Vanderslice Eberwine, Bill Birdsong, Margaret Causey Godwin, Madeline Lovelace, Anna Withers Rollins, Charles B. Godwin, Frances Birdsong Darden, Katherine West, Hazel Maxey, and Elizabeth VanValkenburg. (Courtesy of Elizabeth B. Joyner.)